Historic England

Liverpool

Hugh Hollinghurst

AMBERLEY

Acknowledgements

To the staff at the local history section of the Sefton Library Service who helped me to use their archive. To Roger Hull for his help and advice. To Historic England for archive images and Britain from Above for aerial photos. To the authors of the following books in particular:

Liverpool 800: Culture, Character & History edited by John Belchem
Public Sculpture of Liverpool by Terry Cavanagh
Liverpool: A Landscape History by Martin Greaney
Liverpool: City of Architecture (successor to *Seaport*) by Quentin Hughes
Liverpool (Pevsner Architectural Guide) by Joseph Sharples

To the following for the generous use of their images ('a' top half, 'b' bottom half of page): Paul Breen 7a, 18b, 40a, 72b; Chris Docherty 31a; Paul Hollinghurst 31b, 33b, 51b; Industrial Society 29b; Liverpool Record Office 12b, 42a; Peter Owen 20b, 63a; Charles Roberts/Online Transport Archive 37b.

To my wife Joan as always for her understanding, support and patience.

Photos on pages 9b, 11b, 13a, 15a, 15b, 19b, 21b, 23b, 29a, 32b, 44b, 55b, 57b, 60a, 61a, 63b, 66a, 77a, 77b, 79a, 83b, 88b, 89a, and 95b are by the author.

First published 2018

Amberley Publishing
The Hill, Stroud, Gloucestershire, GL5 4EP
www.amberley-books.com

Copyright © Hugh Hollinghurst, 2018

The right of Hugh Hollinghurst to be identified as the Author of this work has been asserted in accordance with the Copyright, Designs and Patents Act 1988.

ISBN 978 1 4456 8123 8 (print)
ISBN 978 1 4456 8124 5 (ebook)

British Library Cataloguing in Publication Data.
A catalogue record for this book is available from the British Library.

Origination by Amberley Publishing.
Printed in Great Britain.

Contents

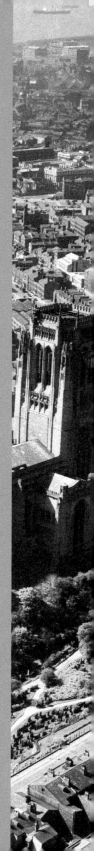

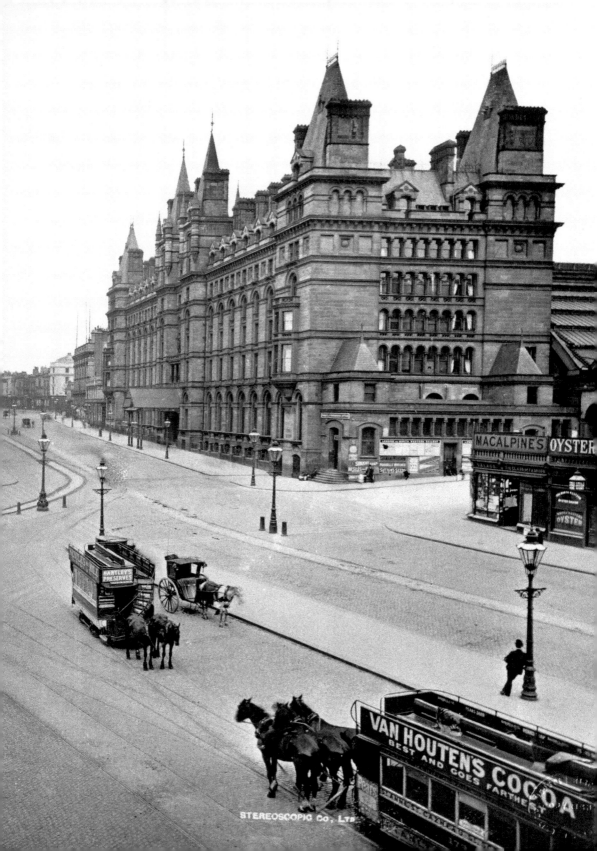

Introduction

Liverpool is wedded to the sea. In 1207 King John gave a charter to a place with a muddy pool in order to transport his invasion force to Ireland. When the Old Dock was created out of the pool in 1715 it was the first commercial enclosed wet dock in the world. Throughout the eighteenth century the town and its docks grew to become the world's first mercantile dock system, and eventually Liverpool established its claim in the nineteenth century of being the second city of the empire.

In 1830 the Liverpool & Manchester Railway linked the two towns with the first 'intercity' service in the world. A network of railways developed that fed the docks and connected them to each other culminating in the 1890s with the Overhead Railway, which ran the whole 13-mile length of the dock system. The Pier Head became the hub of passenger transport. From here radiated a network far and wide: trams to all parts of the city, a railway and ferries across the Mersey, ships over the Irish Sea, and liners across the Atlantic and beyond to all points of the globe. Finally, in 1934, the Mersey tunnel, then the longest road tunnel in the world, transformed communication with the Wirral.

Liverpool's wealth was put to good use. In the early nineteenth century the Lyceum and other establishments promoted education and learning. Growing confidence and ambitions led to the opening of St George's Hall in 1854, which included a grand hall, concert room and law courts. Its classical design and decoration emphasised Liverpool's claim to be a vital part of a new empire. This was followed by a series of outstanding buildings along William Brown Street, most notably the Walker Art Gallery, a library and a museum, to enhance the cultural life of the city. The first of four universities was incorporated in 1903 with the original red-brick university building. Beautiful parks with quality housing were developed on commercial lines with national competitions for the best design.

In 1907 the first of the iconic waterfront buildings (the 'Three Graces') was built. The Port of Liverpool building set the tone by extolling the importance of the port in the British Empire across the world. The Liver Building rivalled anything in the United States in a grandiose statement of commercial opulence and the Cunard headquarters blocked the view of the headquarters, from the Pier Head, of its rival White Star Line. The importance of the cotton trade for Liverpool was highlighted by the construction of an imposing Cotton Exchange in 1907. Many other prestigious commercial and business buildings followed. Construction of the mighty Anglican cathedral began in 1904 and was completed in 1978; the modern Catholic cathedral took five years to build. The cosmopolitan character of Liverpool contributed much to its prosperity and achievements, particularly in the nineteenth century. Besides other parts of England, people came most of all from Ireland following the potato famine but also significantly from Scotland and Wales. However, the city's diversity long predates the post-war influx of people. It's Chinese community was formed in the 1800s and its Jewish community in the mid-1700s.

The Second World War wrought great destruction; traditional handling of goods and passenger traffic dramatically reduced. Then more people arrived, this time from the Caribbean, but decades of discrimination and lack of investment in the city led to the Toxteth Riots of 1981. Those divisions have, thankfully, been healed and the city reinvigorated, helped first by the International Garden Festival of 1984 and then by its role as European Capital of Culture in 2008.

Today, cruise ships have returned, the northern docks are now equipped to handle the largest container ships and the waterfront has been rejuvinated to enhance Liverpool's status as a World Heritage City.

Docks

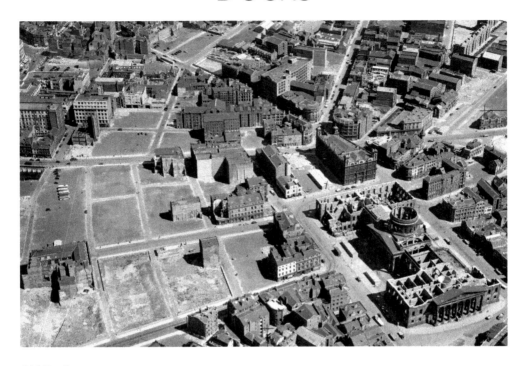

Old Dock

In 1207 a muddy pool on the banks of the Mersey caught King John's eye as a suitable harbour for his fleet's invasion of Ireland, and Liverpool received its charter. Out of it the Old Dock was fashioned in 1715, the first commercial enclosed wet dock – a town-changing – and indeed world-changing – event. It had involved the merchants in huge financial risk, which was amply repaid after ten years of great courage and persistence. The dock was filled in when it outgrew its usefulness and Liverpool's fifth Custom House was constructed on the site. An aerial view of 1946 shows its shell (bottom right) after it had been gutted by fire in the 1941 Blitz. (© Historic England Archive. Aerofilms Collection)

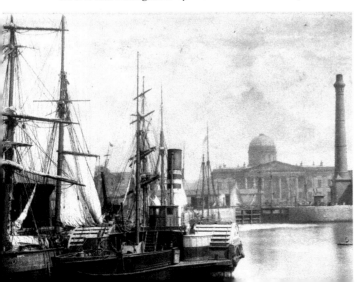

John Foster Junior's Custom House

The fifth Custom House, opened in 1838, was designed by John Foster Jnr. He and his father, John Foster Snr, spanned a period of forty-seven years as town surveyors and promoted the classical style in public buildings that characterise Liverpool to this day. At the time it was the largest structure in the town. This photo taken in the 1870s from the Canning Dock shows the imposing west-facing side that was to impress incoming ships. For balance, the other side facing the town is identical. (Historic England Archive)

Custom House in Victorian Times

This watercolour, one of a series painted by Charles Warren Clennell in 1844, shows the north façade of the Custom House. It is viewed as you approach it along Castle Street, which runs from the left-hand corner of the aerial view opposite. The north side of the Custom House faced the Town Hall – dome to dome – at the other end of Castle Street and is the most impressive (only the central part is visible from this point of view).

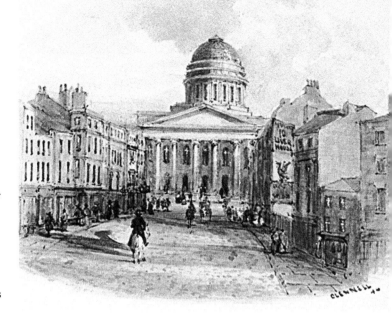

Custom House in Edwardian Times

In this photo from 1907 (from the same viewpoint as the picture above) the mode of transport has changed dramatically with the advent of trams, and some of the Georgian buildings have been replaced by Victorian ones. Those that remained were almost completely destroyed during the war, as can be seen in the aerial photo opposite, or demolished in subsequent redevelopment. The other end of Castle Street towards the Town Hall still has a similar mixture of Georgian and Victorian architecture. (Historic England Archive)

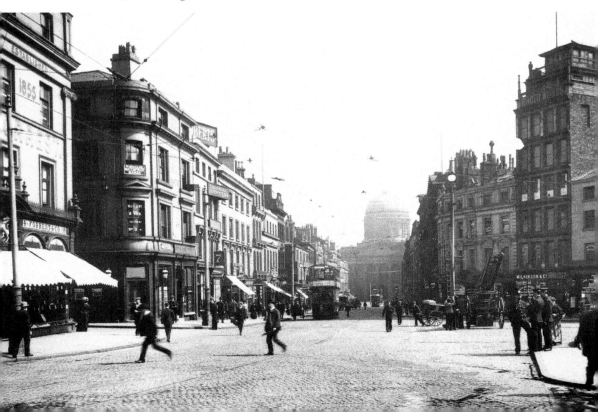

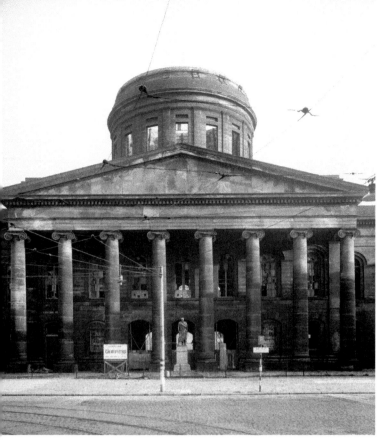

Custom House in the War

The derelict state of the north-facing side of the Custom House, sometime between the Blitz of May 1941 and its demise in 1947, is transparent. Its forthcoming demolition was announced at a press conference on reconstruction (!) in Liverpool to provide work for the unemployed. At least some of the rubble was used to build up sea defences along Crosby Beach to the north of the city. It could, however, have been difficult to find a good continued use for it even as a post office. This had been recognised as far back as 1910. (Historic England Archive)

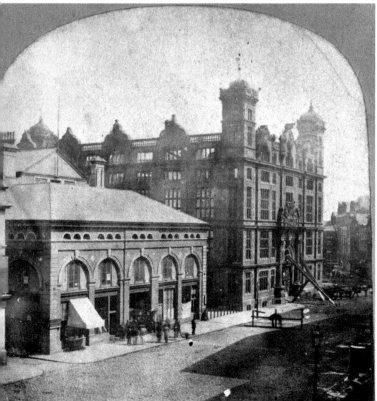

The Sailors' Home

The Sailors' Home, visible on the other side of the Custom House in the aerial view opposite, fared little better. The fine appearance of its neo-Elizabethan Tudor-style exterior was spoilt by its forbidding prison-like interior. It provided sailors who were on leave with educational and recreational facilities, but it was also a place where seamen and captains could meet for mutual benefit. The unsuitable accommodation of an institution of 1847 and changing patterns of employment led to its decline, closure in 1969 and subsequent demolition. (© Crown copyright. Historic England Archive)

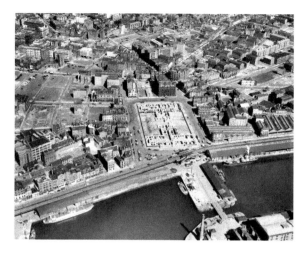

Above: Custom House near the End

The Custom House is in its final stage, razed to its foundations. The walkway between the Canning Dock on the left and the Salthouse Dock on the right in the foreground now forms the main entrance to the Albert Dock area. The Overhead Railway station is on the near side of the Custom House. If you imagine the Old Dock in place of the Custom House, the pool from which it was formed ran inland towards the top left-hand corner of the photo, following the course of Paradise Street and Whitechapel and finishing at Byrom Street. This, with its rising ground, formed a defensive peninsula and promontory on which the castle was built. (© Historic England Archive. Aerofilms Collection)

Below: Old Dock Today

The surrounding area is now occupied by the Queen Elizabeth II Law Courts (which echo the shape of the castle) and the shopping centre Liverpool One. The remains of the Old Dock can be observed through a window in the pavement and visited underground. The row of fountains is a memorial to William Hutchinson and represents the cycle of the tides and phases of the moon. William observed the height of every high water from 1768 to 1793 and his measurements were used to derive the first publicly available tide table in the United Kingdom.

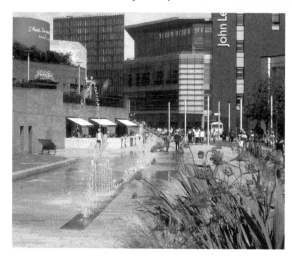

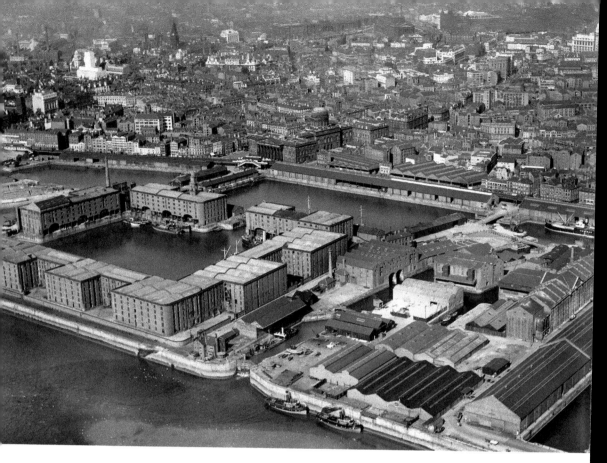

Albert Dock, 1934

This was the year the first Mersey road tunnel was opened, and one of its ventilation shafts gleams brand-new white in the left-centre distance. The Albert Dock is in the left-centre foreground. Beyond it is the Salthouse Dock and to the left the Canning Dock, both still in use at the time. In the centre foreground Duke's Dock (now no more) is still operational. King's Dock, whose tip can be glimpsed in the bottom right-hand corner, has been filled in. The site in between is now occupied by the Conference Centre. The dome of the Custom House can be seen just above the centre of the photo. The Albert Dock was designed by Yorkshireman Jesse Hartley, dock surveyor from 1824 until his death in 1860, and officially opened in 1846 by Albert, Prince Consort, in whose honour it was named. Albert would have delighted in the dock's innovations: the loading and unloading of ships directly from the warehouses; its fire resistance through a combination of cast-iron, brick, sandstone and granite; and a hydraulic cargo-handling hoist system, the first of its kind in the world. A tower seen in the middle of the left-hand block on the far side of the dock was demolished in 1957. (© Historic England Archive. Aerofilms Collection)

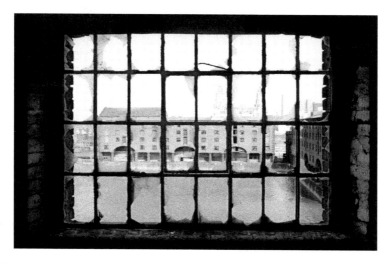

Above: Albert Dock, 1981
The dock had been designed for sailing ships and was, even by the end of the nineteenth century, unable to cope with the increasing size of vessels. Uses were found for it until after the Second World War, but over the next decade it was run-down, became silted up and closed in 1972 as containerisation took over. This view of 1981 taken through a window shows the pitiable state of the fabric. (Historic England Archive)

Below: Albert Dock, 2017
A present-day look through the window of a dining room on the top floor of the Merseyside Maritime Museum with splendid views over the dock and the waterfront. The dock was on the verge of being demolished but was saved by initiatives set up by the Merseyside Development Corporation. Now the largest collection of Grade I-listed buildings in the country, it is also one of the most visited. It is flourishing as a retail Mecca for visitors, and also houses the Beatles Exhibition, Tate North and the Maritime Museum.

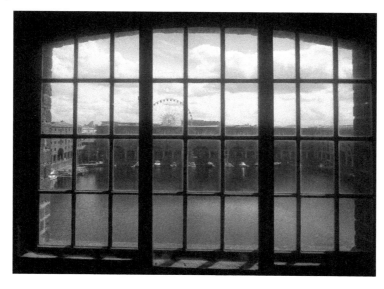

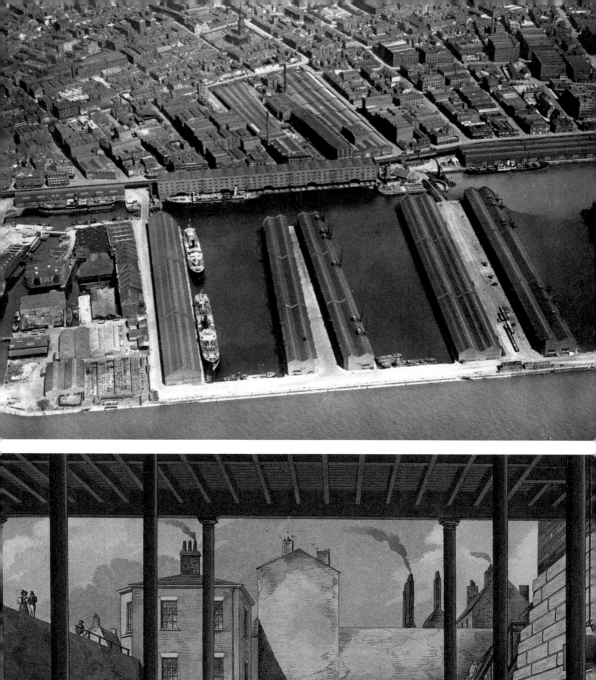
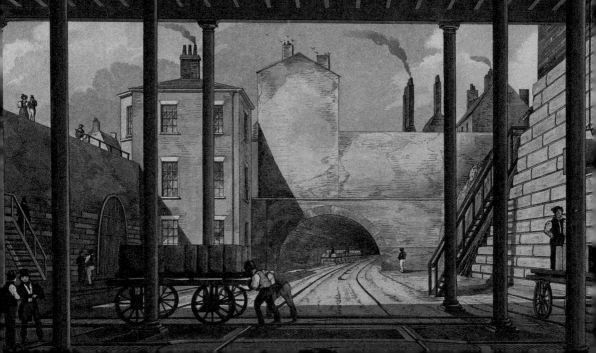

Opposite above: King's Dock and Wapping Dock
This 1927 aerial view shows what appears to be one dock. In fact it was originally two and shows how the dock system could change over time. King's Dock was the first to be completed in 1788 on the seaward side where the two arms are now. Wapping was opened later in 1855 on the landward side to connect the docks lying either side of it. The two docks were combined in the 1890s. Beyond the warehouse are the sheds and track of a freight terminal developed from the dock terminus of the Liverpool & Manchester Railway when it was constructed in 1830. (© Historic England Archive. Aerofilms Collection)

Opposite below: Wapping Warehouses, Liverpool & Manchester Railway
This contemporary print shows the exit from the tunnel that connected with the main passenger line at Edge Hill and can be seen to this day. Freight was more important than passengers for the railways of Liverpool from the start until containerisation in the 1970s. The print shows the cable between the rails that hauled the trains to the top and also the turntable mechanism that enabled the trucks to be transferred from one track to another. The goods were hoisted from this level to warehouses above.

Below: Wapping Warehouse by the Dock
One end of the Wapping Warehouse alongside the dock on the landward side was destroyed during the war, but the columns of the surrounding colonnade have been kept (to the right of the photo). It was converted into residential apartments in 1988 with some fine views over to the Wirral, which are now obscured by later developments. The elliptical arched openings housed hydraulic cranes to speed up cargo handling.

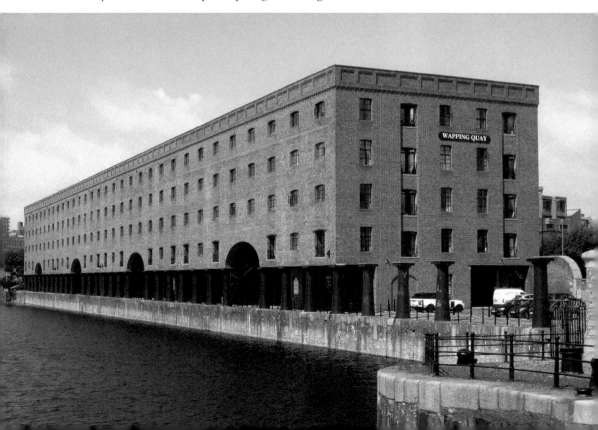

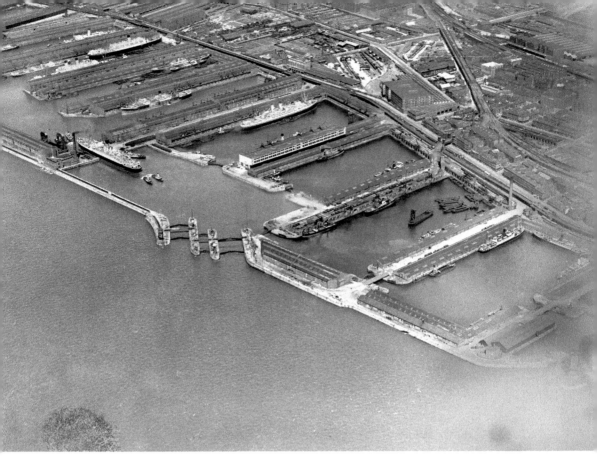

Bramley Moore and Huskisson Docks

A 1927 aerial view shows how the docks spread northwards (as also southwards) along the shoreline from the Old Dock. They specialised in their own commodities – the Bramley Moore dock in the foreground in coal. Jesse Hartley engineered a high-level link from it to the main railway system in 1857, which can be seen coming from the top right-hand side of the aerial photo to the coaling station on the far side of the dock. Coming later, the Overhead Railway (running centre-right to top-left along the dock road) was forced to ground level to avoid clashing with it. In the centre are the two branches of the Sandon Dock with its striking warehouse in between and furthest away the three branches of the Huskisson Dock. (Liverpool MP William Huskisson played a part in national politics in the early 1800s.) The middle one (No. 2) was where the SS *Malakand* blew up during the Blitz and the dock was so badly damaged it had to be filled in. Notice the large ships, one of them being maneuvered by tugs from one dock to the other. (© Historic England Archive. Aerofilms Collection)

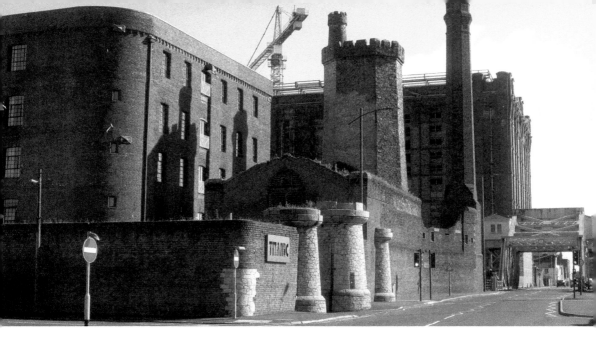

Above: Stanley Dock

Stanley Dock was the only one in Liverpool to be constructed inland and not out from the foreshore. Opened in 1848, it connected the Leeds–Liverpool Canal with Collingwood Dock through a lifting bridge (right of photo). The completion of the Leeds–Liverpool Canal in 1816 facilitated the transportation of raw materials (particularly coal), finished goods (even bridges for the docks) and agricultural produce. In so doing, it brought additional prosperity but removed the remnants of agriculture in the town. Two associated warehouses were built on the northern (left of photo) and southern sides of the dock. They were the first warehouses designed for both rail and hydraulic power This was provided by the Stanley Hydraulic Power Centre (centre-right of photo) with associated accumulator towers. In 1900 a huge tobacco warehouse (centre of photo) was constructed inside the dock. It was the largest brick building in the world and is now being converted into apartments. Jesse Hartley protected his docks with a stupendous set of walls and gateways, one of them pictured here.

Below: Stanley Dock Titanic Hotel

The northern warehouse has now been converted into a hotel themed on the White Star Line's RMS *Titanic*, which had strong local connections. The warehouse originally had five bays, two of which were destroyed during the war, now replaced by the hotel extension.

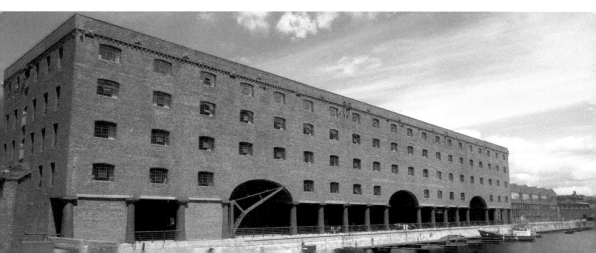

Waterfront

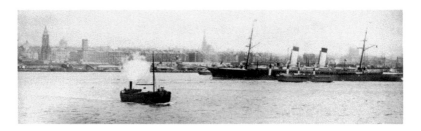

Above: Waterfront, 1887

Our Lady and St Nicholas' Church can be clearly identified to the left of the photo but it was another two decades before the iconic Three Graces appeared on the right. The ship is the National Line's SS *America*, which sailed the North Atlantic route to the United States but quickly surrendered the Blue Riband to Cunard's *Etruria* and *Umbria* and, unable to compete, was sold to the Italian navy. Like her Cunard rivals, she carried sails but had only two masts instead of three. (Historic England Archive)

Below: The Three Graces

Seen in an aerial photo of 1934, the first of the Three Graces to be constructed was the Port of Liverpool Building on the right, opened in 1907; it was followed by the Royal Liver Building on the left in 1911 and the Cunard Building in the middle in 1917. Behind the port of Liverpool Building, the George's Dock Ventilation and Control Station is in the final stages of being constructed for the opening of the first Mersey road tunnel. St Nicholas' Church is hidden behind the Liver Building but the Goree warehouses are clearly visible immediately behind the Cunard Building. The Riverside station is to the left of the warehouses that run alongside the left of Prince's Dock. Note the three loops for trams to turn around at the end of their run. (© Historic England Archive. Aerofilms Collection)

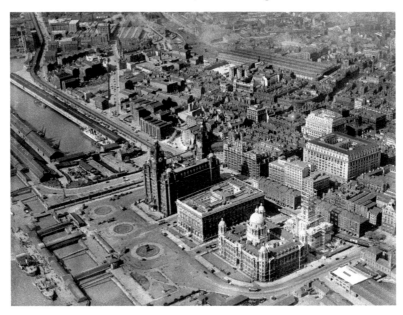

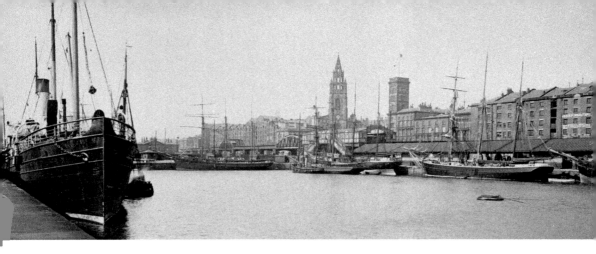

George's Dock

The Three Graces were constructed on the site of George's Dock, named after George III and opened in 1771, which had become obsolete as it was only fit for sailing ships. In this photo taken during the last decade of the nineteenth century, it is still operational. The reclamation of land from former docks in Liverpool started with the Old Dock's conversion into the Custom House. It has been a continuing process from then until now and will be into the foreseeable future. (Historic England Archive)

Waterfront, 1997

The circular tracks for the trams to turn around have been transformed into landscaped gardens and the Goree Warehouses have been swept away in the widening of the Strand. Gone too is the Riverside station. Since this photo of 1997 a cluster of high-rise buildings has sprung up to the right of the dock behind the *Post and Echo* building. The waterfront has been further altered by the construction of a tunnel and cutting to bring the Leeds–Liverpool canal through from the Stanley Dock to the Albert Dock. (© Historic England Archive. Aerofilms Collection)

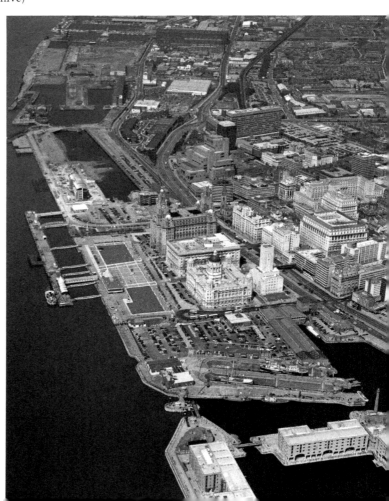

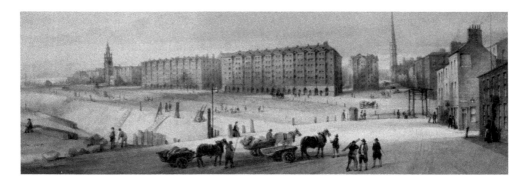

Above: Goree Warehouses

The Goree Warehouses, built in 1793, then burnt down in 1802 and rebuilt, were named after a slave embarkation island off Senegal, West Africa. As can be seen in an engraving of 1822 showing George's Dock during reconstruction, they were ideally situated to service it. They were designed, or certainly approved, by John Foster Snr (who came from Cumbria) and acted as a model for others; for the next fifty years standard clauses were included in future contracts governing height, building lines, and the duration and materials of construction with special regard for fireproofing. Also included was provision for arcades at ground level to protect pedestrians from bad weather, hence the name 'Goree piazzas'. However, developers became reluctant to include these, involving as they did extra expense without benefit to themselves, and they were eventually discontinued. (Historic England Archive)

Below: Mann Island

John Mann, a local oilstone dealer who died in 1784, gave his name to the island that was formed when George's Dock was constructed. In a watercolour of 1844, we are on Mann Island looking from the new George's Baths (alongside George's Dock) to James Street. The corner of the dock is to the left with the Goree Warehouses ahead and St George's Church beyond (on the site of Derby Square at the end of Lord Street). In front is the low bridge crossing the cut joining Canning Dock and George's Dock. It ceased to be an island when George's Dock was filled in and the Three Graces built there. It is now occupied by three modern buildings.

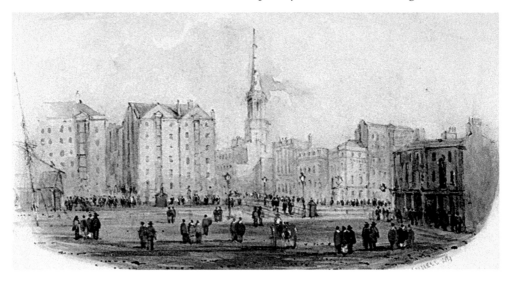

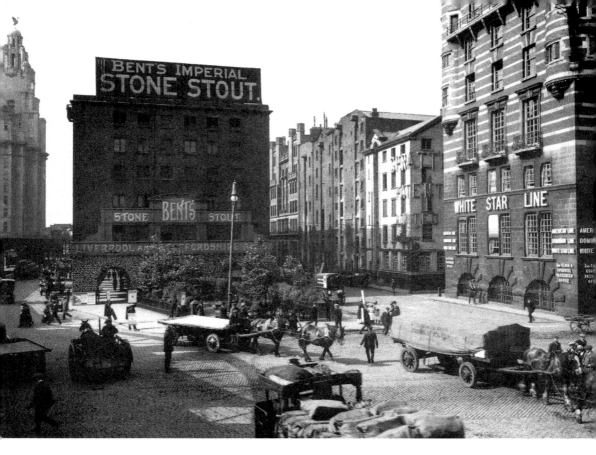

The Strand, 1919

In this view of 1919 the area thrives with activity. Horse-drawn traffic predominates but a horseless wagon is making an appearance. The estimated 415 miles of streets in Liverpool with granite setts, close joints and Portland cement foundations supported heavy goods traffic until well into the twentieth century. The protection that the arcading of the Goree Warehouses gave during inclement weather can clearly be seen, augmented by the Overhead Railway (the 'Dockers' Umbrella') just visible to the left. However, apart from giving shelter, the Overhead presented danger of life (with at least one fatality) to anyone standing up on the open-top deck of a bus. (Historic England Archive)

The Strand, 2017

The Goree Warehouses survived until after the Second World War when they were demolished following war damage. This eased the passage for north/south traffic and made one side of the inner ring road possible, as shown in the photo. Albion House, the White Star Headquarters Building, is on the right in both photos on this page.

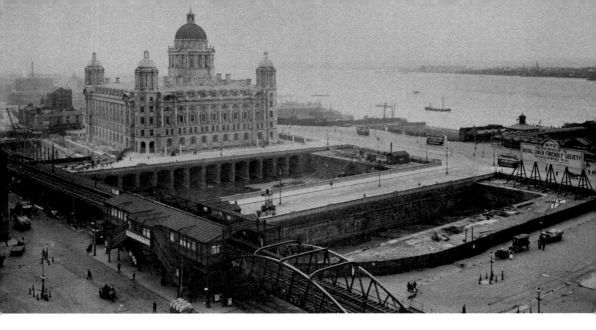

Above: Port of Liverpool Building
This photo taken from the top of St Nicholas' Church in the summer of 1907 shows George's Dock drained and divided into three. The Port of Liverpool Building has just been completed by the Mersey Docks and Harbour Board, and work has started on the Liver Building to occupy the space nearest to the camera. There is an excellent view of the Overhead Railway and the Pier Head station in the left foreground; this was the hub of Liverpool's transport network. The Overhead linked up with the Pier Head itself and from there ferries could be taken across the Mersey and ships across the Irish Sea, over the Atlantic Ocean and further. The trams terminated at the Pier Head, and not far away James Street station on the Mersey Railway gave access under the river to Birkenhead, the Wirral and beyond. (Historic England Archive)

Below: Port of Liverpool Dome
The Port of Liverpool Building was built for the Mersey Docks and Harbour Board, the largest port system run by a single organisation. The constitution of the board ensured that it was free from political bias and influence. Membership was coveted by an aspiring business elite, a major element in its success. The dome is linked with the dome of the Custom House and through it to the dome of the Town Hall. The patterning on the interior of the dome is modelled on that of the Pantheon in Rome, emphasising Liverpool's claim to be second city of the empire.

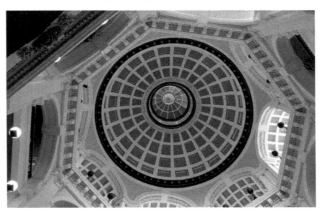

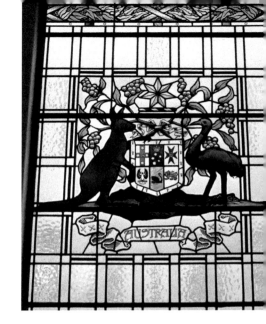

Port of Liverpool Windows
The magnificent stained-glass windows inside the building are dedicated to the countries of the British Empire, a clarion roll call of its extent at the start of the twentieth century. They point to Liverpool's unique position as a unifying link with the empire overseas. Illustrated is the coat of arms of Australia and there are others representing dominions, colonies and protectorates. (© Historic England Archive)

George's Dock Ventilation and Control Station
In 1934 a 'fourth grace' was added on the landward side of the Port of Liverpool Building: the George's Dock Ventilation and Control Station. It served as a ventilation shaft for the Mersey road tunnel and associated control mechanisms and offices. Although art deco in character like the other tunnel structures, it has Egyptian styling and blends well with the buildings around it. (It is centre-right of the photo peeping from behind the modern buildings on Mann Island.) These include the RIBA North, the Royal Institute of British Architects' first centre for architecture outside London. In between them and the Museum of Liverpool on the left is the extension of the Leeds–Liverpool Canal completed in 2009.

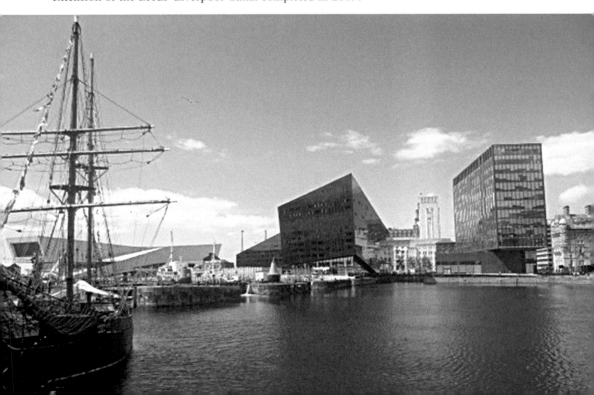

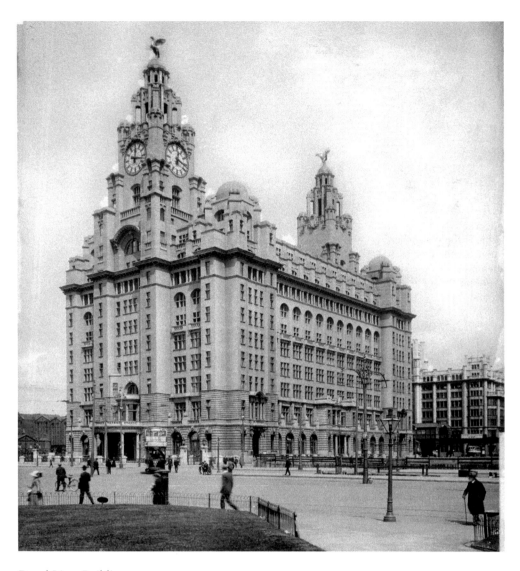

Royal Liver Building

The Royal Liver Building with its two Liver birds perched on top, one looking symbolically to the sea and the other to the city, is the most iconic of all the buildings in Liverpool. Perched on top of domes raised on high by towers with gigantic clocks, the birds advertise the city with immediate, extravagant and romantic impact. Following on from the traditional classical design of the Port of Liverpool Building, the American look of the Liver Building was making a statement of modernity to rival the other side of the Atlantic. Seen here in 1916, soon after it was opened in 1911, it is one of the first large-scale reinforced concrete buildings in the world, and certainly the first in Britain – the ancestor of skyscrapers. The four clock faces, arranged for maximum visibility from all quarters, are larger than those of Big Ben and the mechanism of the clocks the largest in the country that are driven electronically. The Royal Liver Group for whom the building was originally constructed has recently been rebranded as Royal London but kept a Liver bird (cormorant) as its logo. (Historic England Archive)

Above: Before the Royal Liver Building

George's Dock is seen here in the 1890s before it was drained to make way for building purposes. This is the part where the Liver Building was later constructed, so you have a view from this angle of the Pier Head station of the Overhead Railway and St Nicholas' Church immediately behind it. To the right of them is the tower of a semaphore (a system of sending messages by holding the arms or two flags or poles in certain positions according to an alphabetic code) signal station that linked Liverpool and Holyhead before the development of the electric telegraph. (Historic England Archive)

Below: Royal Liver Building from Above

Below is a view from one of the newly constructed tower blocks. The Royal & Sun Alliance and *Liverpool Daily Post and Echo* complex is immediately below to the left with St Nicholas' spire peeping from behind the hotel beyond. The Liver Building and, to the left of it, the George's Dock Ventilation and Control Station stand out with the Albert Dock beyond. Further on to their left a line of docks, Canning, Salthouse and Wapping, stretch away into the distance. On the right a ferry approaches the terminal. The Salthouse Dock took its name from the salt works that occupied the site. Completed in 1754 at major financial risk, it is a reminder of the importance of salt (and also coal) exports for the prosperity of Liverpool from the early eighteenth century onwards. Liverpool's internal economy also benefited from processing these nearby raw materials.

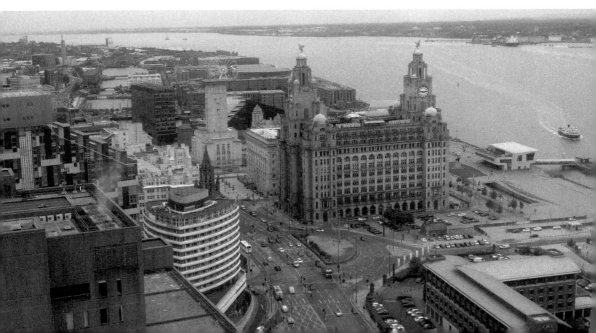

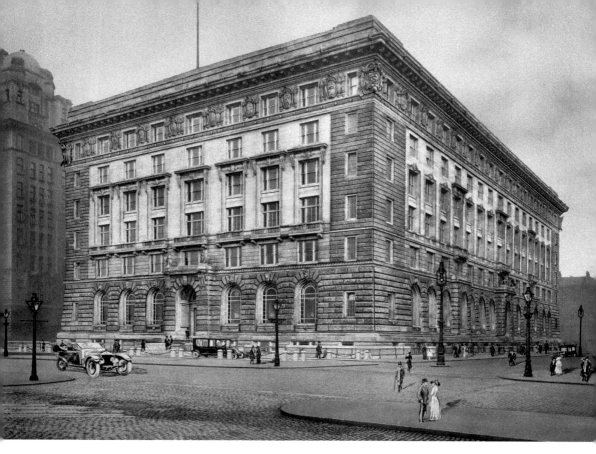

Cunard Building

The Cunard Co. was founded in 1840 in Liverpool when it was awarded a contract to carry mail across the Atlantic. For decades the company's biggest ships such as the *Aquitania* sailed from Liverpool but with the arrival of the Queens its premier services were transferred to Southampton. The Cunard Building was completed in 1917, so the 1916 photo shows it before completion and is described as 'worked up' due to cars and pedestrians having been painted onto the negative. (Historic England Archive)

Cunard Building Decoration

The building was inspired by the grand palaces of Renaissance Italy and the exterior is lavishly decorated with symbolic sculptures. As illustrated, they include portraits representing people you might meet on some of the company's exotic cruises. Classical figures, such as Neptune, god of the sea (a Liverpool favourite), and Athene, goddess of wisdom, adorn the doorways. Coats of arms represent different countries of the world. The chiaroscuro effect of light and dark was produced by the driving rain carrying soot into the crevices. (© Historic England Archive)

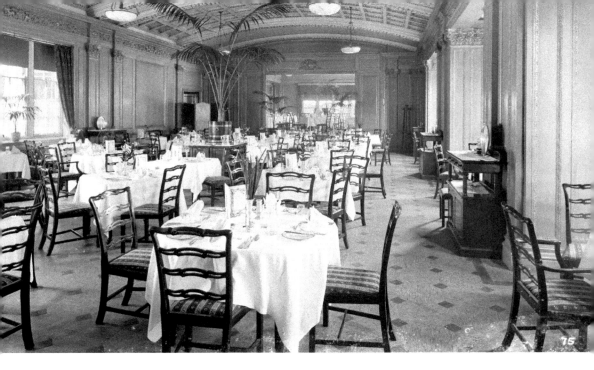

Above: Cunard Building Restaurant

All classes were catered for in the Britannia Rooms, as pictured, to separate second- and third-class passenger accommodation. Staff had their own dining and smoking rooms and a ladies' restroom. Besides passenger facilities there were offices, services and the lavishly decorated company's boardroom. Naval architects also worked there. The building has now been adapted to provide office accommodation for a variety of companies, but the main corridor link across from one main entrance to the other survives, and the use of marble there from different quarries on the Continent also indicates global outreach. Other interesting features that remain include the baggage handling facilities in the basement. (Historic England Archive)

Below: Victualling Meeting on Board RMS *Aquitania*

RMS *Aquitania* undertook her maiden voyage from Liverpool to New York in May 1914, just before the outbreak of the First World War. After military service in both world wars, she was scrapped in 1950. The amount of food needed for an extended voyage was prodigious and this photograph was commissioned by the Cunard Steamship Co. to show a victualling meeting held in 1914 to arrange the necessary provisions. There is a wide variety of headgear and dress in the carefully composed group of thirty-three representing the many different organisations and ranks involved (but not a woman in sight!). Similarly, in view of the ultra-cosmopolitan character of Liverpool residents and seamen of the time, there is not much evidence that this mix was reflected in the managerial hierarchy. (Historic England Archive)

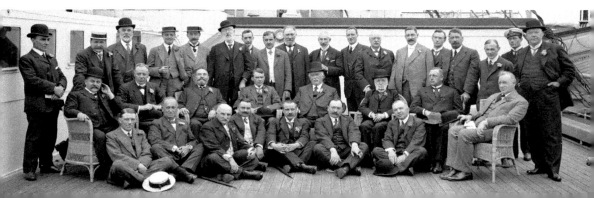

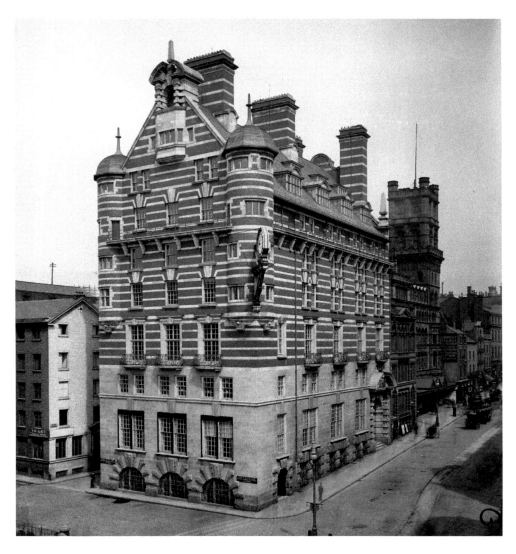

Albion House

Albion House, the headquarters of the White Star Line, was designed by Norman Shaw, a distinguished national architect. It bears strong resemblance to a previous design of his for New Scotland Yard in London on the banks of the Thames: half French chateau, half Venetian Town Hall. It was the first of the twentieth-century, new-style tall office blocks in Liverpool that were to change the face of cities throughout the world. When completed in 1898, before the arrival of the Three Graces, it dominated the area, as shown in this contemporary photo, upstaging the tower of James Street station. This, seen behind Albion House, was built to house the lift mechanism and water storage needed to power the deep lifts at the station. It was destroyed by enemy action during the war but its counterpart at Hamilton Square in Birkenhead on the far bank of the Mersey has survived. Albion House originally had a fine aedicule (a decoration in the form of a little house) at the top of the building but this was damaged in the war and replaced by a plain triangular pediment. At the same time the clock on the near corner of the building was removed (its face, end on to the viewer, is barely visible). (Historic England Archive)

White Star Line Office

The White Star Line public office as shown in 1898 is extremely utilitarian compared with the exterior. There is no attempt to disguise the stanchions and girders supporting the ceiling, which consists of fireproof terracotta panels. Although the White Star Line had moved its headquarters from Liverpool to Southampton in 1907, the loss of the *Titanic* was announced from Albion House. The captain and many of the crew were from the Liverpool area. The building has now been converted into a *Titanic*-themed hotel. (Historic England Archive)

Oceanic Frieze

Norman Shaw was also commissioned by the White Star Line for the interior design of their RMS *Oceanic*. This painting was part of a frieze adorning the ship, which sailed between Liverpool and New York. It represents Liverpool (along with New York, Britain and America), easily identified by Liver birds on her dress and on a shield to her left. When the *Oceanic* was built in 1899, she was the largest ship in the world. (Historic England Archive)

Transport

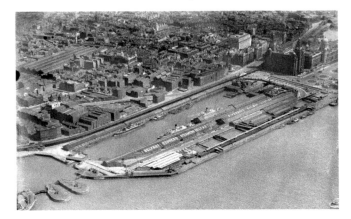

Above: Prince's Dock and Landing Stage

Prince's Dock was the first one built in the nineteenth century when the Prince Regent was serving in place of George III. The construction of a floating landing stage in 1876 enabled the largest ships to moor in the open river. When joined to the neighbouring George's Landing Stage situated to the south, it extended to nearly half a mile – the largest floating structure in the world. The vital link of a floating roadway gave access to it at all times whatever the state of the tide. Both were scrapped in 1974, when transatlantic services from Liverpool ended, but have since been replaced on a smaller scale. In an aerial view of 1927 Exchange station is top left with the façade of the Cotton Exchange to the right of it. Also prominent is the Liver Building (top right) and the white of the recently completed India Buildings. The rail connection to the Riverside station comes from the bottom left-hand corner across the swing bridge at the entrance to the dock. (© Historic England Archive. Aerofilms Collection)

Below: Riverside Station

A view of around 1900 shows a very crowded scene at the landing stage with Riverside station on the extreme left, which enabled passengers to transfer from boat trains straight onto the ocean liners. Specials were run through from London, particularly for the transatlantic trade. Liverpool was peculiarly well situated for this and had benefited through sugar trade from as early as the 1660s and subsequently through the notorious slave trade. (Historic England Archive)

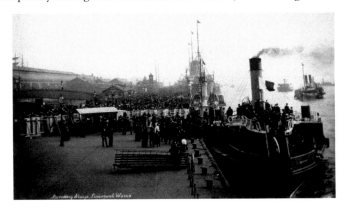

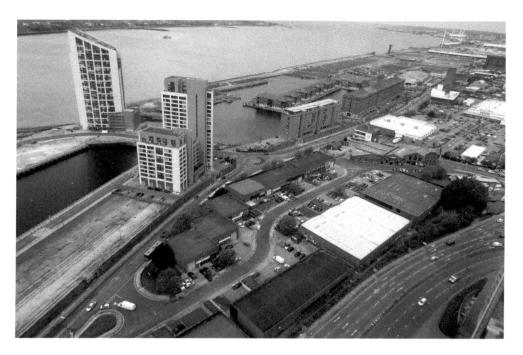

Above: Riverside Station Approach

Riverside station was accessed by the construction of two tunnels, totalling over 2 miles in length, which linked with the main line at Edge Hill. The course of the line can be traced on this modern view taken from above. Riverside station was on the far side of Prince's Dock to the left of the photo. The line then passed over a swing bridge (hidden behind the nearer tower block) that connected Prince's Dock with Waterloo Dock to the north of it. The tracks then passed the Waterloo Warehouse, crossing over the dock road, and made a connection with the Waterloo Goods Yard now occupied by a business park. The northern docks stretch away into the distance.

Below: Train from Riverside

A train from Riverside is passing Waterloo Warehouse (now converted into apartments) and crossing the Dock Road to link up with the Waterloo Goods Yard. It is double headed to lift the train up the steep gradient through the tunnels to reach the main line at Edge Hill. This was probably in 1957 as the Overhead Railway was being dismantled with the stanchions still in place, while some of the supports for the decking are lying on the road to the left of the leading locomotive.

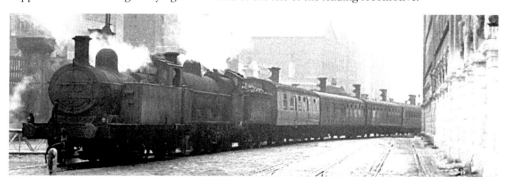

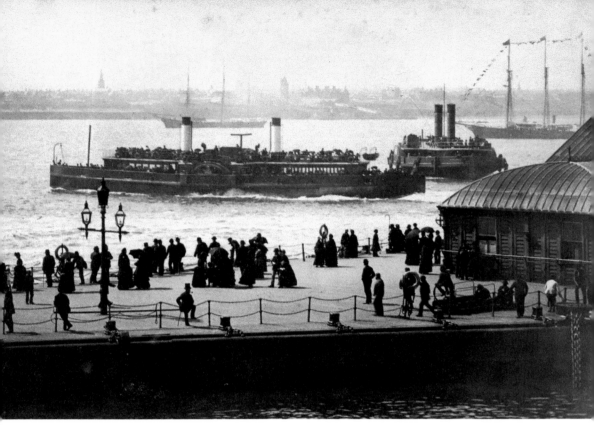

Landing Stage Ferries and Promenading

Taken sometime between 1860 and 1890, this photo shows the landing stage with ferries, a paddle steamer and sailing ships, one festooned with flags, looking over to Birkenhead and Wallasey. It is a great place to congregate, socialise and enjoy the fresh air. People of all sorts and ages promenade along the waterfront to enjoy the view, marvel at the latest technological advances and delight in each other's company. Later, a journey on the Overhead Railway would afford the same experience on an even larger scale. Or you could take a ferry here from the south end of the landing stage and enjoy views from the river or from the other side on the Wirral. (Historic England Archive)

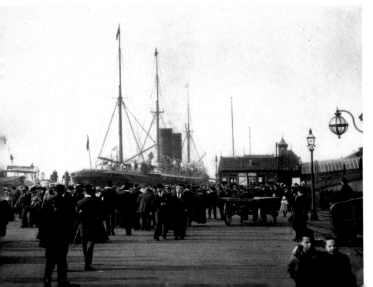

SS *Etruria* at the Landing Stage

This scene of around 1900 shows Prince's Landing Stage with a varied crowd, most making their way towards the SS *Etruria*. When commissioned in 1884 for the Cunard Line, she was one of the most luxurious ships afloat. The *Etruria* was one of the last two Cunard steamships to carry auxiliary sails, and the three masts for these can be seen in the photo. She ended her days in a collision with a hopper just off the pier in Liverpool in 1908. (Historic England Archive)

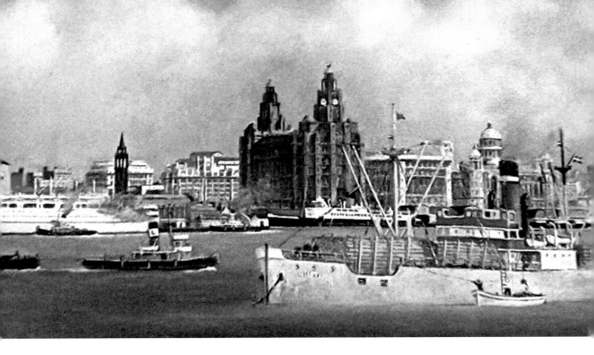

Above: Landing Stage, 1960s

An imaginary view of the early 1960s depicts a busy scene at the landing stage. From the left at the back: the Canadian Pacific Line's *Empress of Canada* attended by two Alexandra Towing Co. tugs; an Isle of Man ferry (the *Tynwald*?); a Birkenhead ferry (the *Woodchuck*?); and the *St Bruno* or the *St Tudno*, which used to sail to Llandudno. In the centre a J. H. Lamey Ltd tug is towing a barge and in the foreground the timber carrier *Gustav* is flying a Swedish flag.

Below: A Queen at the Landing Stage

In 2015, the 175th anniversary of the Cunard Line, *Queen Victoria*, *Queen Mary II* and *Queen Elizabeth* met on the Mersey. It was an occasion to remember the great days of Liverpool's connected globalisation. At one time Liverpool had forty-four different consular representatives in the city – more than any other except New York. The view shows the waterfront scene from the tower blocks on the left to the Albert Dock on the right with *Queen Elizabeth* in between. Liverpool more than any other great port has an immediacy of maritime and urban connection. Ocean-going liners berth alongside the city.

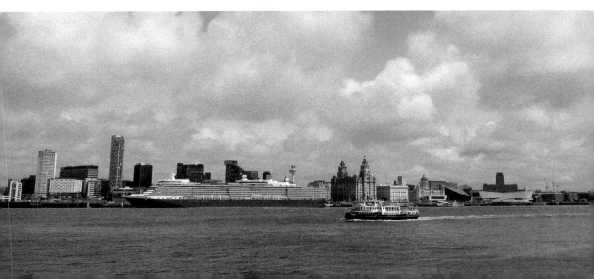

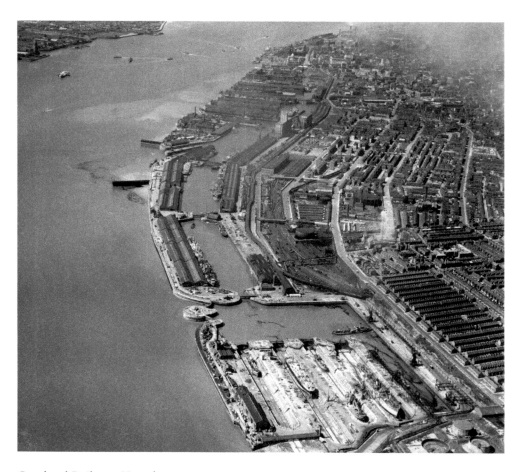

Overhead Railway, Herculaneum

During the rapid expansion of the docks north and south from the site of the Old Dock during the latter part of the nineteenth century, it became increasingly clear that there was a need for improving communication between the two ends of the system. A railway had to be overhead to avoid conflict with the ground-level tracks of the extensive existing lines that fed into the docks. So in the 1890s the Overhead Railway, the first electrified one in Europe, was constructed from Seaforth at one end in the north to the Herculaneum Dock in the south. Here, it appears in the aerial view of 1946 running to the right of the Harrington Dock (further away from the viewer) past the original terminus by the Herculaneum Dock visible in the foreground. An extension from there to the Dingle was constructed in the late 1890s, like one at the northern end, to draw extra traffic into the system. This can be seen turning round to the right (east) bridging the Cheshire Lines Railway route and tunneling into an underground terminus at the Dingle. The magnificent entrance to the tunnel can still be seen. The oil tanks (bottom right-hand corner) were constructed in 1922 in Liverpool's bid to be the north-west's major bulk oil facility as part of a diversification plan after the First World War. Stretching away to the north beyond Harrington Docks are Toxteth and Brunswick Docks. (© Historic England Archive. Aerofilms Collection)

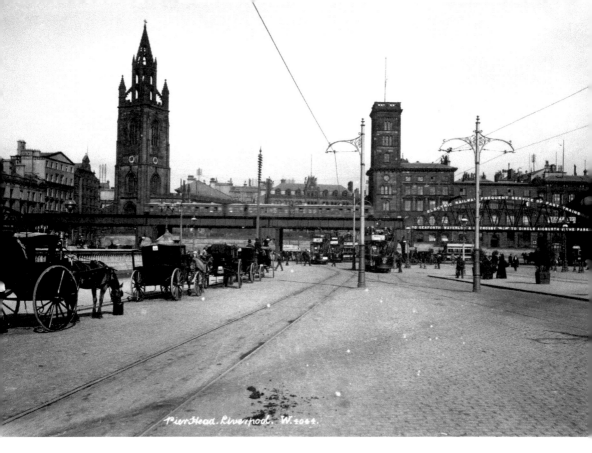

Overhead Railway Pier Head Station

The north end of the Pier Head station of the Overhead Railway can be seen on the right of this photo taken before 1910. This was when the Liver Building was constructed, which then hid the railway from this point of view. It was the main station on the railway and a line of horse-drawn cabs in the foreground wait for fares. Behind them is St Nicholas' Church and to the right of centre is the tower of the semaphore signal station. (Historic England Archive)

Overhead Railway Remains

In 1956 inspection of the Overhead Railway revealed serious corrosion in the decking caused, above all, by the sulphurous exhausts from the dock locomotives working underneath. No finance was forthcoming for a hugely expensive replacement by a company that barely ran at a profit. It was dismantled the following year. Remains of the stanchions that once held up the decking survive embedded here in the wall by the Wapping Warehouse.

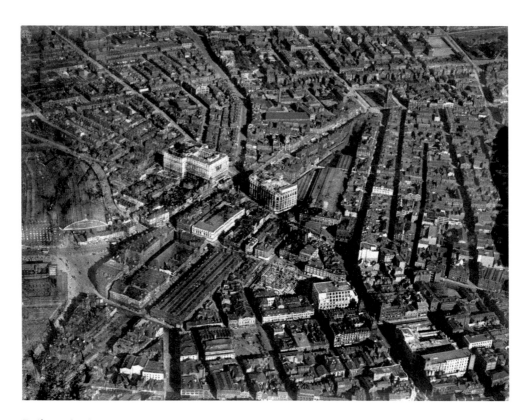

Railway Stations

Liverpool was well equipped with stations to welcome commuters and visiting businessmen by rail from all quarters of the compass: Lime Street from the north, south, east and west (via Crewe and Chester); Central from the east and west (via the Mersey tunnel); and Exchange from the north and east. In the 1924 aerial photo one of the train sheds of Lime Street station can be seen centre-left. Central station is to the right of centre and the tracks lead away from it into a tunnel underneath St Luke's Church (top right). Exchange station is off picture to the left. The triangle of white buildings in the centre from the apex clockwise is the Adelphi Hotel, Lewis's and Blackler's. Below that, what looks like a train shed is the long roof of the original St John's Market designed by John Foster Jnr and opened in 1822 but demolished and rebuilt as St John's Precinct during the 1960s. (© Historic England Archive. Aerofilms Collection)

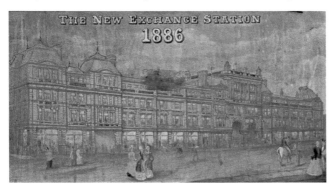

Exchange Station
A stained-glass panel in the Railway Hotel situated opposite the Exchange station portrays its magnificent façade, preserved after the station's closure in 1977. (© Historic England Archive)

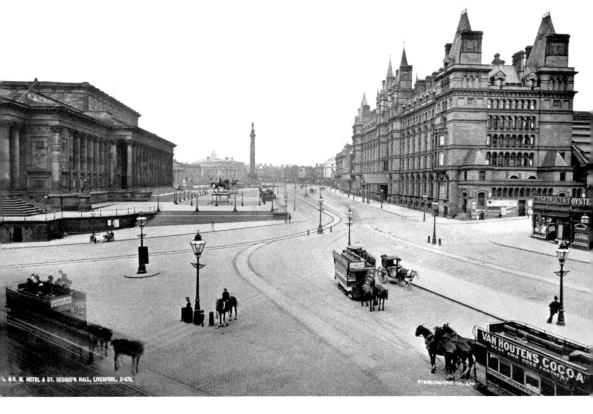

Lime Street Station

This view was taken between 1887 and 1900, with St George's Hall on the left and the Hotel in front of Lime Street station on the right. Open-top horse-drawn trams are accompanied by a lone horse and rider, and horse and trap. Van Houtens Cocoa, first manufactured in 1828, is still for sale! The Liverpool & Manchester Railway, the first intercity passenger railway, originally terminated at Crown Street further out near Edge Hill station. This claims to be the oldest continually operated station in the world (from 1830). In 1836 the line was extended from Edge Hill to Lime Street station, the first railway terminus in central Liverpool. The line later became part of the London & North Western Railway, which opened the North Western Hotel.

Central Station

Central station was the last terminus to be opened in central Liverpool by the Cheshire Lines Railway, in 1874. It is pictured in 1911, on the right looking up to Lewis's and the second Adelphi Hotel, which had been purchased and developed by the Midland Railway, a partner in the Cheshire Lines Committee that ran the line. Cranes indicate that work started that year on the demolition of the second Adelphi and its replacement with the third. The Mersey Railway terminated in a lower level of Central station. When the underground line was extended across the city centre in 1977 to link up with this, Central station's upper level was closed and completely rebuilt to serve the new line. The present (lower level) single platform handles over 5 million passengers per annum, one of the busiest underground platforms in the country. (Historic England Archive)

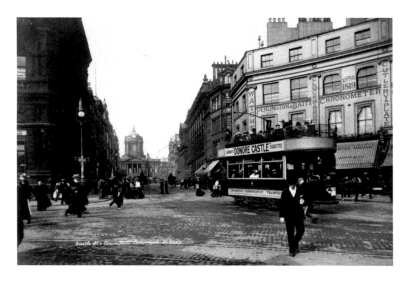

Above: Open-top Tram

Around the turn of the nineteenth century an open-top tram has come from the Town Hall, in the distance at the end of Castle Street. It is turning to go through Derby Square and proceed up Lord Street. (The names incidentally record the rivalry between the families of Lord Derby and Lord Molyneux.) The square is on the site of the Molyneux Castle, which was demolished to make way for St George's, the first parish church of Liverpool, itself demolished in 1899 to be replaced by Queen Victoria's Monument. (Historic England Archive)

Below: Trams in Lord Street

Trams have crossed in Lord Street on their way to and from Derby Square. Electrification of the tramlines was introduced in 1897 when Liverpool Corporation bought the Liverpool United Tramway and Omnibus Co. By 1902 75 miles of track had been electrified and routes were extended along tree-lined boulevards to the suburbs. These lines were well used by those who had moved to the suburbs but still worked in town, although many walked to work. Tram stock and infrastructure were severely damaged by enemy action and a depot fire in 1947. The Corporation decided replace them with buses and the last tram ran in 1957. (Historic England Archive)

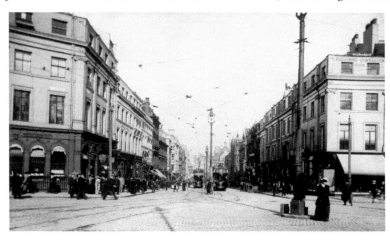

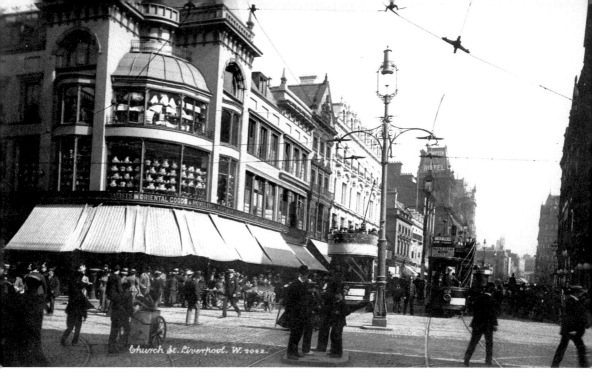

Above: Trams in Church Street

At the junction of Lord Street and Church Street, this busy scene is filled with tramcars and pedestrians at the turn of the nineteenth century. On the corner lies Bunney's General Store, which advertises a number of goods in its windows, including washing jugs and basins. Ahead on the left a tower of Compton House can be seen, now Marks & Spencer. All these 'tram' photos show a lack of goods traffic and the motor car had yet to come. Both these streets are now pedestrianised, at the time the longest stretch in the UK. (Historic England Archive)

Below: Tram No. 762

Preserved Liverpool tram No. 762 is pictured on the Wirral Transport Museum and Heritage Tramway at Birkenhead, which gives rides from the ferry to the museum on Europe's first street tramway. Seventy-seater No. 762 was built at Edge Lane Works, Liverpool, in 1931/2 in the crimson lake and white livery of the time. Soon afterwards the tram livery was changed to privet green and white, which No. 762 gained when it was rebuilt in 1939. After it was withdrawn in 1955, the lower saloon became a bowling green clubhouse, but it was rescued and restored to its original state and livery by the Merseyside Tramway Preservation Society.

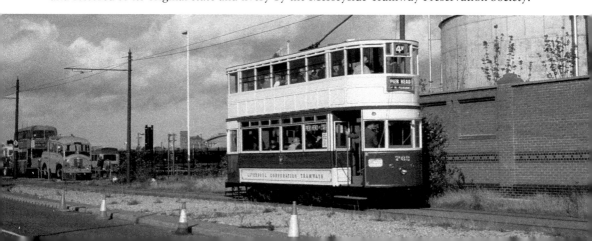

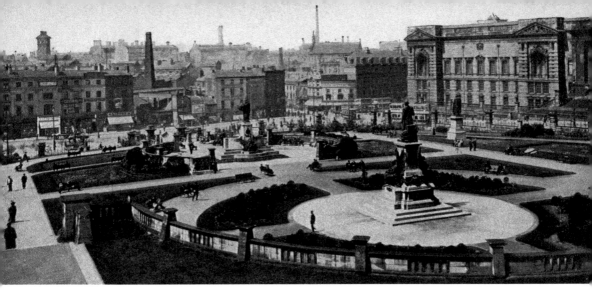

Above: St John's Gardens, Edwardian Era

'St John's Ornamental and Memorial Gardens' were created in 1904 on the site of St John's Church (demolished in 1899) and its cemetery. Most of the bodies of the 80,000 buried there had been reinterred. The photo was taken soon after opening and the newly built museum extension is on the right. The industrial skyline is noticeable with the tower of the Hatton Garden fire station prominent on the left. The two most significant memorials in the garden are to those of the King's Liverpool Regiment who died in the Afghan, Burman and Boer wars and to William Ewart Gladstone (four times prime minister). (Historic England Archive)

Below: Mersey Road Tunnel

This 1934 aerial view shows how the area at the bottom of St John's Gardens, gleaming white, has been transformed by the entrance to the Mersey road tunnel. Below it the clock tower of the Municipal Buildings can be seen in the very centre at the bottom of the photo. They stand alongside Dale Street, under which the first part of the tunnel was constructed using the 'cut and cover' method. St John's Gardens, with the two circular surrounds of the prominent memorials standing out, are enclosed on the left by the cultural buildings along William Brown Street and on the far side by St George's Hall. Beyond the hall are (from left to right) the Empire Theatre, the North Western Hotel and Lime Street station. Bottom right is the General Post Office, now sadly reduced by bombing and development. (© Historic England Archive. Aerofilms Collection)

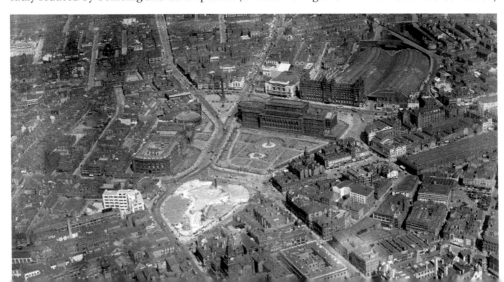

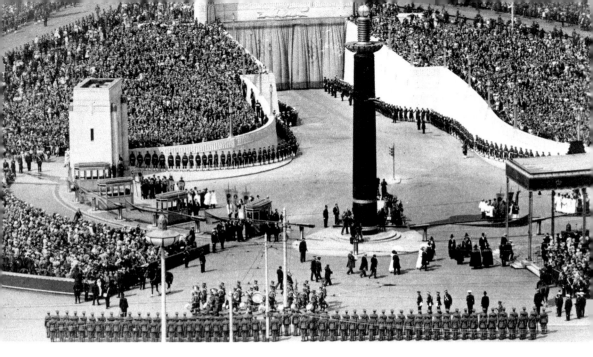

Above: Mersey Road Tunnel Opening

In 1934 the gardens witnessed the opening of the longest underwater road tunnel in the world. It was nine years in the making and supervised by the city engineer John Brodie (born in Shropshire and inventor of the goal net, appropriately in this great footballing city). With great pomp and ceremony George V named the tunnel Queensway in honour of Queen Mary. The lighting column this side of the river has not survived but other decorative features have: the triumphal arches, decoration over the entrance arch and pay booths. 'Queensway' leading to Birkenhead was joined in 1971 by 'Kingsway' leading to Wallasey, opened by Elizabeth II in honour of her father. (Historic England Archive)

Below: St John's Gardens, Elizabethan Era

This photo was taken probably in the 1960s showing the tunnel entrance in relation to the gardens. The Liver Building in the distance and the Municipal Buildings in the centre hold prominent position and to the right the first and, at the time highest, multistorey office block has made its appearance. Since then tower blocks have sprouted up around it and the skyline is noticeably different from the 1904 view opposite. (Historic England Archive)

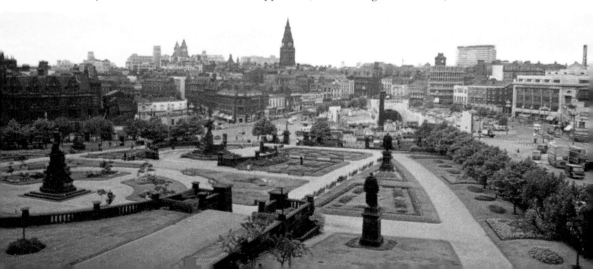

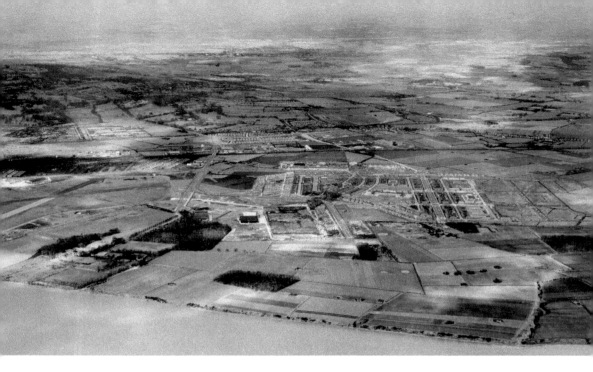

Above: Liverpool Airport
The River Mersey is at the bottom of this 1947 photo taken from the air. On the far left is the runway that used to stretch down from the old airport buildings to the river. To the right of it, Speke Hall is at the end of the road which runs through the two dark patches of trees towards the shore. In the centre foreground is the former Rootes Securities 'Shadow' Aircraft Factory that, heavily camouflaged, built and assembled aircraft during the war. The fields between it and the river are now occupied by the terminal building of the modern airport and by the runways that now stretch away to the right off picture. (© Historic England Archive. Aerofilms Collection)

Below: Speke Airport Terminal Building
Speke Airport's first service was an Imperial Airways flight to Croydon, South London, in 1930. A fine terminal building in modernist style and control tower were completed in 1940. It was one of the first purpose-built terminals in the world and also the first municipal airport building in Europe. A new runway was completed in 1966 and a new terminal building in 1986. It was renamed Liverpool John Lennon Airport in 2001 with 'Above us only the sky' from his song 'Imagine' painted on the roof, the first airport to be named after an individual in the UK. The original airport building has now been converted into a luxury hotel. (© Historic England Archive)

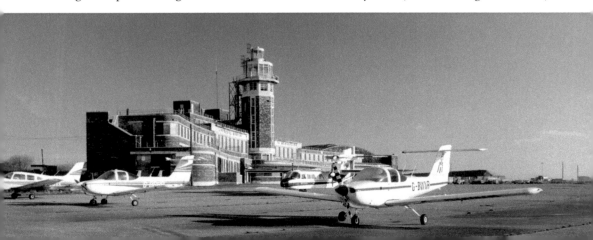

Business and Commerce

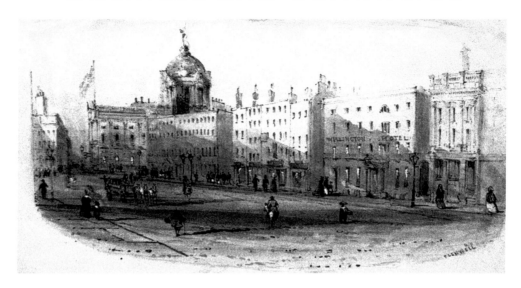

Town Hall: A Georgian View

When the third Town Hall was opened in 1754 it was a landmark occasion for the town, bringing onto one site the additional functions of assembly rooms and exchange. This watercolour of 1844 shows how the Town Hall jutted out prominently into Dale Street (and lopsidedly when viewed from Castle Street) above its neighbours. Although dwarfed now by adjacent buildings, when opened it stood out from the whole town – even more so when the dome was completed in 1802. Soon after, a grand portico was added and it was extended a century later to enlarge the Council Chamber. Its ornamental carvings of foreign trade indicate Liverpool's growing ambitions and the important links between the commerce and politics at the time.

Town Hall: A Victorian View

The Georgian buildings in Dale Street have now been swept away by Victorian developments. You are looking along Water Street from the Pier Head station of the Liverpool Overhead Railway in 1895. The façade of the Town Hall can be seen in the distance jutting out at the point that Water Street turns into Dale Street. Half a century later than the previous view, the buildings are larger and more ornate. Later on the street would be further enhanced by the huge office blocks of Martins Bank alongside the Town Hall, India Buildings further down and nearer on the right, and finally West Africa House framing the entrance on one side and Tower Buildings on the other side. (Historic England Archive)

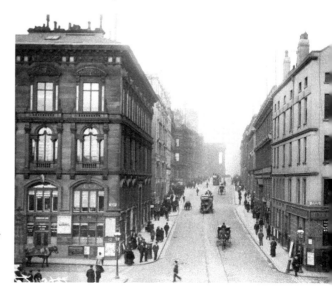

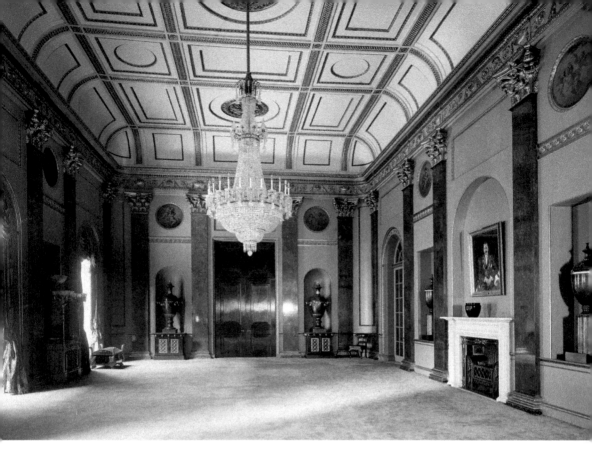

Town Hall Dining Room: An Edwardian View
The Dining Room is the most sumptuous room in the building. Its design, by James Wyatt of the famous architect family of London, dates from 1805. A 1913 photo, possibly associated with changes made at the time, shows its moulded plaster ceiling, elaborate frieze, pilasters of artificial marble in Greek Corinthian style, and painted roundels depicting cherubs and oriental vases in niches. In addition to the fireplace on the right opposite the windows there are stoves in between the windows on the left of more elaborate classical design.(Historic England Archive)

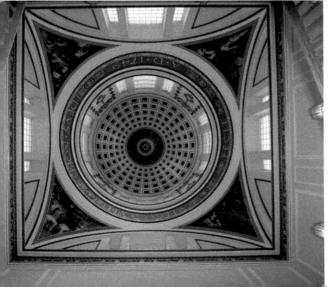

Town Hall Dome
On the ring surrounding the dome (reconstructed in 1795 after a disastrous fire) is the date 'A.D.1749', the year in which the first stone was laid, in the reign of George II. Then, reading from four o'clock anti-clockwise (i.e. from left to right) is the city's motto: 'DEUS NOBIS HAEC OTIA FECIT' (from the Roman poet Virgil), 'God has given us these leisure pursuits'. The magnificence of the staircase hall with the dome overall and the staircase leading up to it shows how the building was originally intended for ceremonial purposes and not municipal business. (© Crown copyright. Historic England Archive)

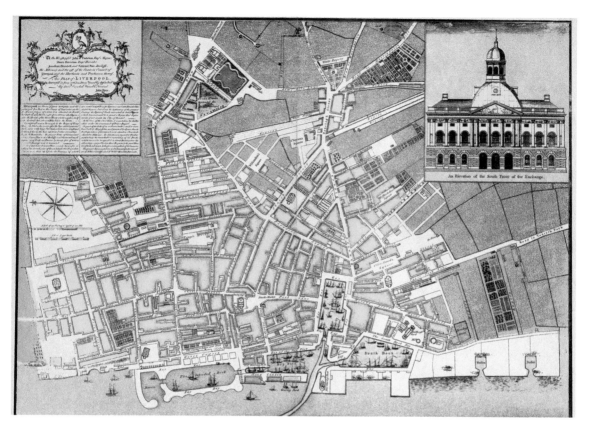

Eyes' Map of 1765

The Town Hall of 1673 is depicted top right in Eyes' map of 1765, which is orientated east (i.e. from the Mersey) as often in early maps of Liverpool. Underneath the Town Hall is the Public Exchange for merchants. It is at the end of Castle Street leading left from the Old Dock and stands below the crossbar (High Street) of the H pattern of streets of the original town: top right Dale Street, bottom right Water Street (leading down to the centre of George's Dock), top left Tithebarn Street and bottom left Chapel Street (leading down to the left-hand edge of George's Dock). The map shows five Anglican churches, meeting houses for Baptists (two), Methodists, Quakers and Dissenters (three), a 'Romish' church and a synagogue. It also shows industrial activity: glasshouses, a salt house, two roperies and shipbuilding along the Strand (never fully developed in Liverpool but very much over the river by Cammel Lairds in Birkenhead). Besides fashionable London-type squares are the docks (from left to right): George's, Canning, Old and Salthouse.

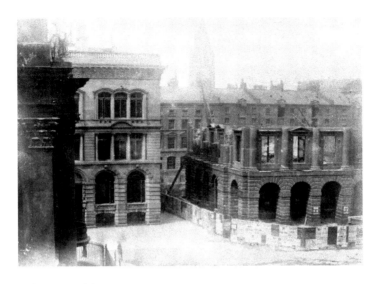

Above: First Exchange Building (just!)

This extremely rare photo of the demolition of the first Exchange Building was taken in the 1850s or early '60s. On the left stand the old buildings in Rumford Street and in the background rises the tower of St Nicholas' Church. A ladder is propped up against the wall inside the protective barrier. (Historic England Archive)

Below: Second Exchange Building

There is a hive of activity on the Exchange flags in around 1900, overlooked by the ornate second Exchange Building completed in 1867. At the centre is Nelson's Monument, on which four shackled prisoners round the base represent Nelson's four great naval victories. Above them, Nelson, one foot on a canon and the other on a fallen foe, is being crowned by Victory. Behind, a figure of Britannia laments his death. A third Exchange Building was partially opened in 1939 but interrupted by the war and not fully opened until 1955. Although perpetuating the classical style of its predecessors, it does so ponderously in stripped classical form. (Historic England Archive)

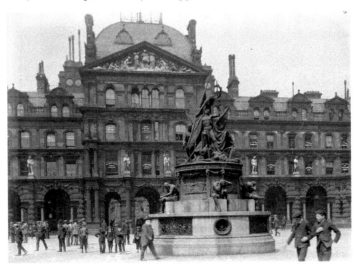

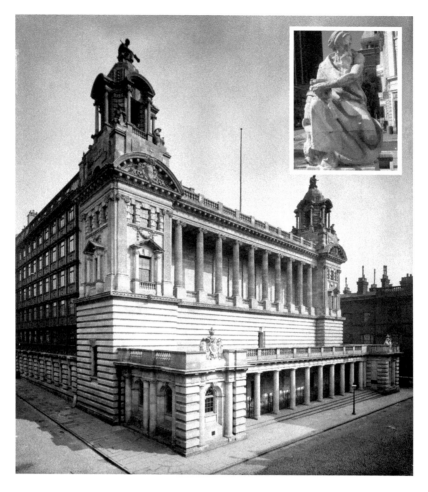

Cotton Exchange

Cotton was extremely important for the economy of Liverpool during the eighteenth century when its ships were infamously involved in the lucrative triangular trade of transporting slaves from Africa to America, then the raw cotton from there to the mills of Lancashire, and goods from there to Africa. Because of cotton, Liverpool merchants supported the Confederate cause during the American Civil War. At one time cotton accounted for 30 per cent of Liverpool's imports and 42 per cent of its exports, and the personification of Liverpool on the top of the Walker Art Gallery sits on a bale of cotton to help identify her. The Cotton Exchange was completed in 1907 to provide a venue for the trading of imported raw cotton destined for the Lancashire mills. The finished goods were then sold worldwide through the Manchester Royal Exchange. The magnificent Edwardian baroque frontage to Old Hall Street was demolished in 1967 and replaced with a modern office façade. However, the decorative and functional side wall (to the left of the photo) has thankfully been preserved. Between these six storeys are panels with classical ornamentation and wreathes, while the wide windows enabled cotton to be inspected scrupulously inside. One of the two sculptures that surmounted the towers (the right-hand one) was rescued and stands in Old Hall Street where the left-hand projecting lodge of the exchange used to be. It represents the River Mersey (*see* inset), who clasps an anchor, tiller and length of rope in his left hand and in his right an urn pouring a liquid like an overflowing cornucopia onto the head of a dolphin. (Historic England Archive)

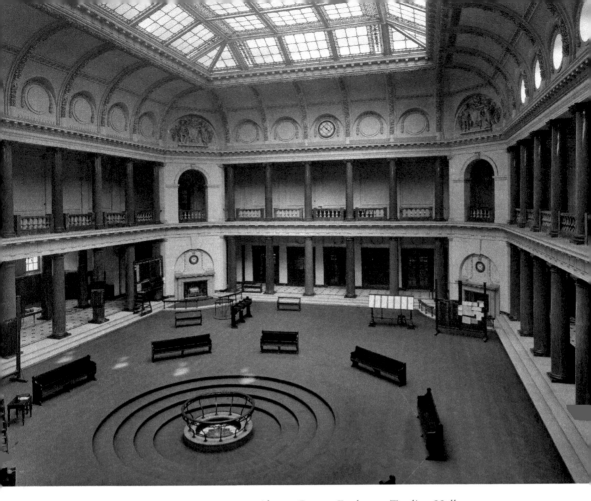

Above: Cotton Exchange Trading Hall
The trading hall of the Cotton Exchange, pictured at the time of opening in 1907, was demolished at the same time as the frontage. The building was equipped with the latest technology for communicating with cotton trading elsewhere in the world, including telephones, and cables linking directly with New York, Bremen and Bombay. No expense was spared in obtaining the columns, monoliths quarried in Norway, polished in Aberdeen, and still preserved. (Historic England Archive)

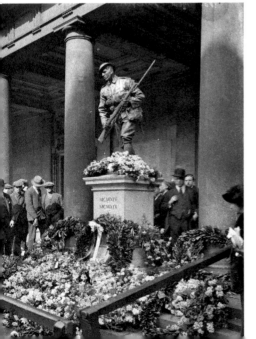

Left: Cotton Exchange Memorial
The corporate spirit was flourishing in the 1920s when the First World War memorial in front of the colonnade was dedicated before a crowd wearing dress and hats typical of the era. It is now situated inside the rebuilt courtyard. The infantryman who can be seen striding resolutely forward has since lost his bayonet and the plaque visible on the wall behind recording the many names of the Cotton Exchange employees who lost their lives in the war has also disappeared. (Historic England Archive)

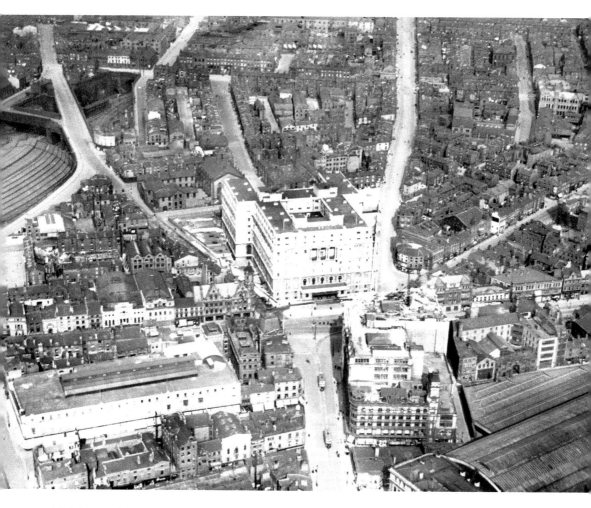

Adelphi Hotel Environs
An aerial view of 1921 shows the third Adelphi Hotel in the very centre of the photo. The neoclassical look of the third Adelphi Hotel, in vogue in the early 1900s for grand buildings on the Continent and in the USA, would appeal to transatlantic voyagers. When opened in 1914, it was considered the most luxurious and prestigious in the country outside London. The department store Lewis's is just below it on the right of Ranelagh Street, which leads up to the Adelphi. A bit of Central station is visible in the bottom right-hand corner while the lines leading into Lime Street station are top left. The prominent building pointing to the bottom left-hand corner is Blackler's department store. Founded by Richard Blackler and A. B. Wallis in the early twentieth century, it closed in 1983 and the building is now used by various retailers. Just above it, the east side of Lime Street faces you with the Futurist Cinema in the middle of the block. (© Historic England Archive. Aerofilms Collection)

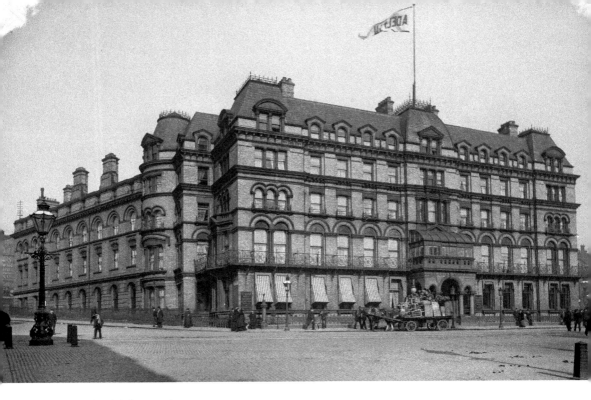

Second Adelphi Hotel

The first Adelphi Hotel was built in 1826 on the site of the former Ranelagh Gardens, which was the first public open space for recreation in Liverpool, opened in 1722 and modelled on Ranelagh Gardens in Chelsea, London. The first Adelphi was replaced by this second one in 1876. In 1892 it was bought by the Midland Railway, part owner of the Cheshire Lines Railway, whose Liverpool terminus was Central station. The hotel was then renamed Midland Adelphi. A horse and cart loaded with furniture stands in front of the hotel in 1896. Soon after the photo was taken the Liverpool Self-Propelled Traffic Association was formed, one of the world's earliest motor organisations and also one of the most innovative. Its heavy vehicle events were of international significance in the development of commercial transport. (Historic England Archive)

Second Adelphi Hotel
Coffee Room

Famous artistes appearing at the Empire Theatre would stay here and first-class passengers would imbibe coffee in this room before embarking on transatlantic voyages. It was a favourite of Charles Dickens, who was well travelled and an expert on hotels; he stayed here before crossing the Atlantic on the Cunard ship *Britannia* to record his experiences in *American Notes* and *The Life and Adventures of Martin Chuzzlewit*. (Historic England Archive)

Above: View from Second Adelphi Hotel
You are looking down Ranelagh Street from the fifth floor of the extension to the Adelphi in 1911. Lewis's department store is on the left with Central station further down. The tower of the Vines is just across the street to the right. In the distance Birkenhead can be seen across the river. If you were staying in rooms with a river view, there would be the exciting possibility of seeing the arrival of the liner that would soon take you across the Atlantic. (Historic England Archive)

Below: Third Adelphi Hotel
Every bedroom in the hotel had a telephone and private bathroom. The leisure facilities included a full-size indoor swimming pool, squash and tennis courts and shooting galleries. The public rooms, decorated in Louis XIV and Louis XVI style, were panelled with sycamore inlaid with rare woods. The standard of catering and service was legendary. A feature was a basement set of heated tanks to keep live turtles for turtle soup (a favourite of Queen Victoria). It was not only served on the spot but exported through the country and beyond. The décor and stateliness of the main rooms were designed to give the same impression as an opulent liner; the doors of bedrooms even opened out onto the corridor as on ships. (Historic England Archive)

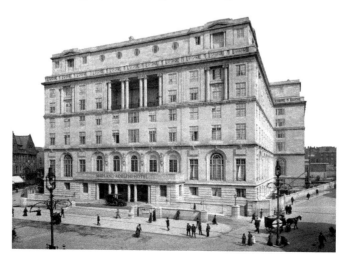

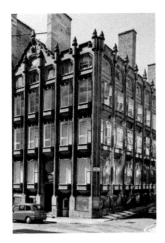
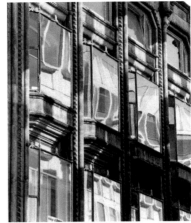

Above: Oriel Chambers

It is difficult to believe that Oriel Chambers was built twelve years before the second Adelphi and half a century before the third. The architectural decoration at the top is of its time, but its construction is decades ahead. It was probably the first building in the world where the exterior was covered with a thin cladding designed to keep out the weather and not hold up the structure. Most of its façade is glass with oriel windows divided by slender cast-iron frames. Its projecting windows reflect its neighbour's, which have been sympathetically designed to enhance in return its neighbour's modernist appearance. The top-storey windows are different with the glazing passing in front of the cast-iron stanchions. (© Historic England Archive)

Below: No. 16 Cook Street

Contemporary No. 16 Cook Street, by the same architect, Peter Ellis, is as revolutionary as Oriel Chambers. The façade is similarly glassed as far as possible and the design an exciting mixture of narrow warehouse with a unifying pattern of arches. The most remarkable feature is hidden from view behind: a spiral staircase, cantilevered out from the building, clad with sheet iron and plate glass with Gothic handrails inside. Peter Ellis was over sixty when he designed these buildings and maybe because of the acerbic criticism of them does not seem to have designed any building of note until his death eighteen years later. (© Historic England Archive)

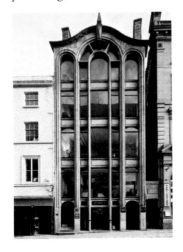

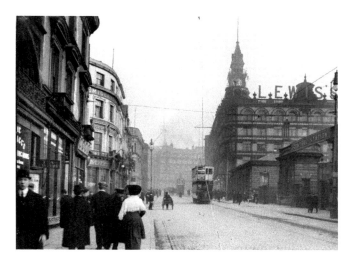

Above: Lewis's
You are looking up Ranelagh Street from the old Central high-level station on the right to the second Adelphi Hotel ahead just before the First World War. Then, as now, the Adelphi is a landmark building at the end of the street. Lewis's department store proudly proclaims itself on the right. It is not to be confused with John Lewis, the national firm, who later had a branch in the city. Liverpool's Lewis's was founded by David Lewis (of Jewish origin), who opened his first store in 1856, and was so successful that he opened other stores in Birmingham and Manchester. Eventually, the firm spread to five other major cities in Britain and took over Selfridges. However, it went into administration in 1991 and closed its Liverpool doors for the last time in 2010. (Historic England Archive)

Below: Lewis's Bombed
This 1942 photo shows the damage of the Liverpool Blitz on Lewis's ahead and neighbouring Blackler's store on the left. The passers-by are taking no notice of the devastation and precarious look of Blackler's. Liverpool was the most heavily bombed area of the country outside London, owing to its strategic importance in securing the importation of food from America. The peak of the bombing lasted from 1–7 May 1941, which put sixty-nine out of 144 cargo berths out of action, inflicted 2,895 casualties and left many more homeless. (Historic England Archive)

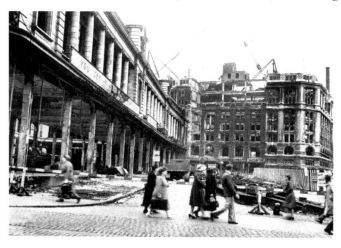

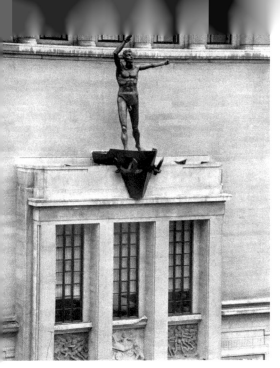

Liverpool Resurgent
The gutted part of the store was rebuilt after the war, the most notable feature being the statue of a nude man over the main entrance on the corner. It was sculpted by Sir Jacob Epstein with the official title *Liverpool Resurgent*, timed to coincide with the centenary of the opening of the store. The sculptor changed the model originally approved by the directors of the firm beyond recosnition and kept it under wraps until the unveiling. Its 'uncompromising masculinity' caused a furore in some quarters then but has been accepted over the years with typical Liverpudlian good humour. (Historic England Archive)

Lewis's from Above
This photo taken from the top of Radio City Tower shows rebuilt Lewis's centre-left and Blackler's tucked into the left-hand corner. Central station is in the foreground with the lines leading underground in the centre to the tunnel mouth in the very middle of the picture. Its new high-level buildings take travellers down to the old lower-level tracks that were used to extend the Northern Line through to Hunts Cross in the 1970s. The green roof of Radiant House, built for the Liverpool Gas Corporation in 1938, can be seen bottom right. It stands on Bold Street, whose long straight line preserves the memory of its origin as a rope-walk. In the distance the tower of the Anglican cathedral breaks the skyline.

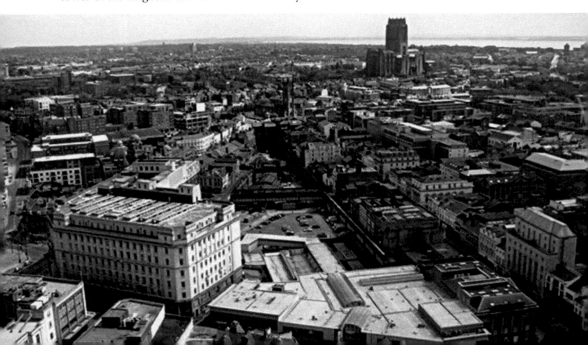

Lyceum

Completed in 1803, the Lyceum provided a newsroom for merchants and professional men. It also contained the rehoused Liverpool Library, which is claimed to have been the oldest circulating library in Europe. After closure and the threat of demolition in the 1970s it has survived as a post office and then through various catering and commercial lettings. Pictured in the early part of the twentieth century, it stands at the head of Church Street and has two beautiful classical façades, the main one facing Church Street and the longer one stretching up Bold Street, as seen here. Note the building works on the Bon Marché building to the left in the distance. (Historic England Archive)

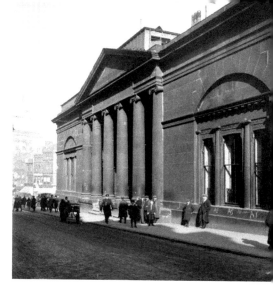

Bon Marché

The original Bon Marché building, as pictured in 1891, was replaced in 1918 and extended in the early 1920s. It was advertised as a 'shopping paradise for women' and 'the most modern store in Britain'. John Lewis acquired both the Bon Marché and the neighbouring George Henry Lee in the 1960s and joined the two buildings with a tunnel and bridge. When John Lewis decided to call all their stores by their own brand name, it caused some confusion with the existing (David) Lewis's department store. John Lewis has now moved to the new Liverpool One. The corner of Compton House, occupied by Marks & Spencer since 1928, can be seen to the left of the photo. (Historic England Archive)

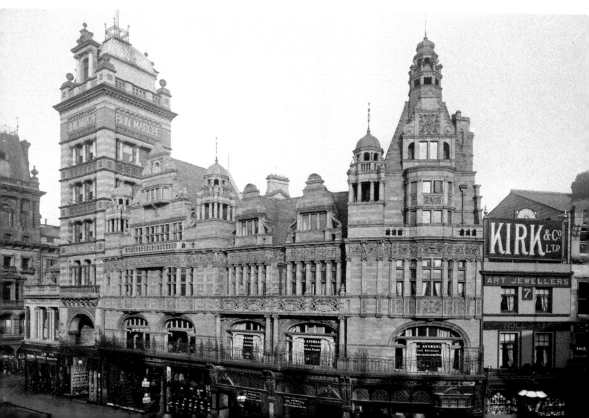

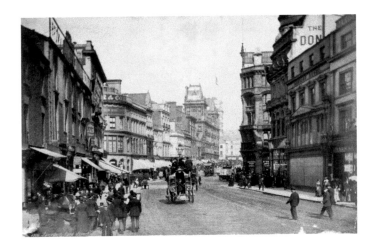

Above: Compton House

Compton House is seen from the other side on the left of this photo taken in 1887, as you look up Lord Street into Church Street, which is crowded with pedestrians, horse-drawn buses and trams. Built in the amazingly short time of eighteen months, on opening in 1867 it was considered superior to any other department store in the world for architectural decoration. In the near universal change of retail occupation in the street since the war, Marks & Spencer has remained here. (Historic England Archive)

Below: Woolworths

Woolworths' huge building opposite Compton House was opened in 1923 and is pictured below in a period photo with its original shopfront. It is an indication of Liverpool's prosperity at the time that the site was considered by Harrod's as a potential branch. It was built on the spot of the recently demolished St Peter's Church, the former pro-cathedral from which the street takes its name, but closed sixty years later. Since then the building has been occupied by various popular retailers but still retains the crossed keys in memory of St Peter at its apex and a cross to mark the old entrance to the church in the pavement below. (Historic England Archive)

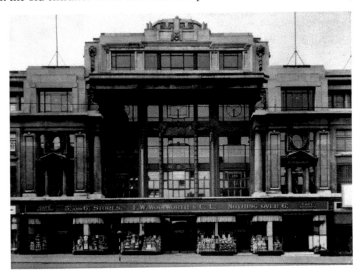

Culture

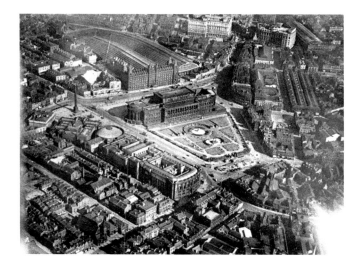

Above: St George's Plateau from the Air

St George's Hall is at the centre of this aerial photo of 1924, with Lime Street station beyond it. The back of the row of cultural institutions on William Brown Street can easily be identified (from left to right): the County Sessions House, the Walker Art Gallery, the (circular) Picton Reading Room, the Library and Museum, and the Museum Extension and Technical School. The area to the bottom right of St John's Gardens is seen as it was before the Mersey road tunnel was built. (© Historic England Archive. Aerofilms Collection)

Below: North Western Hotel and the Empire Theatre

This 1887 view shows the 330-room North Western Hotel on the right opened by the London & North Western Railway in 1871, later used as railway offices and now converted into student accommodation. Beyond it is the old Empire Theatre opened in 1866, at the time the largest in town. The new Empire was opened in 1925. Behind the Wellington column the Walker Art Gallery can be glimpsed to its left and the County Sessions House to its right. Horse-drawn trams are also shown at work. (Historic England Archive)

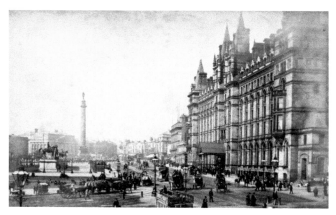

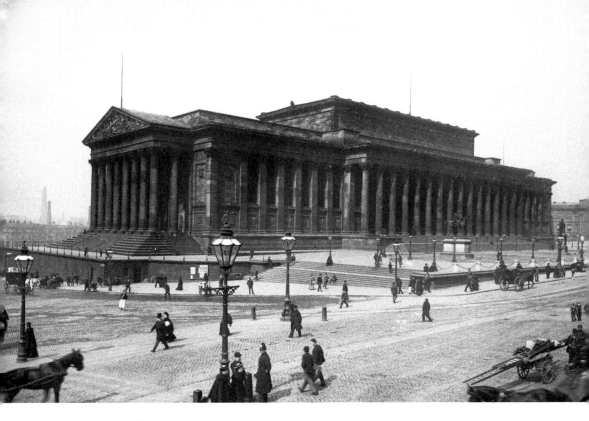

St George's Hall

On the other side of the plateau is St George's Hall as pictured in 1895. The white plinth of Prince Albert's equestrian statue can be discerned in front of the hall (more clearly below). The policemen in the foreground were familiar figures directing the traffic here, at the time horse drawn or handcarts. Distant industry is visible to the left. From this angle you can appreciate why St George's Hall was said by Norman Shaw to be 'one of the great edifices of the world'. The other end is different but equally monumental. (Historic England Archive)

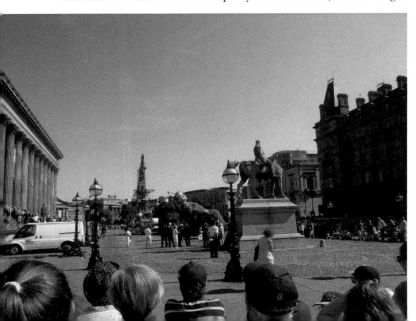

St George's Plateau

The plateau was the scene of great gatherings of passionate feeling on occasions. In the Liverpool general transport strike of 1911 the vast crowds assembled here were forcibly dispersed by police, with hundreds injured. More peacefully, the plateau witnessed the arrival of the Great Puppets in 2014; spectators are seen here waiting for Granny centre to wake up!

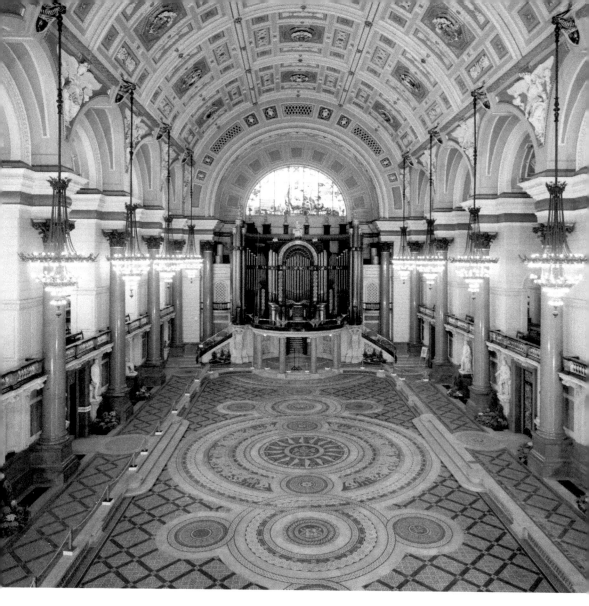

St George's Hall, the Great Hall

In 1839 a competition was held to design a hall where dinners, concerts and festivals might be held. It was won by Harvey Lonsdale Elmes, a young architect from London. Another competition for a new assize court was held at the same time, which Elmes also won, and he suggested that the two buildings should be combined. The outside was designed in a grand Greco-Roman style and the rich decoration on the ceiling, windows and walls of the Great Hall portrays Liverpool as an inheritor of Rome's pivotal position in an empire. Prominent are Neptune, Roman god of the sea, and Mercury, god of trade, as elsewhere throughout the city. Its greatest glory is the floor covered with 30,000 Minton tiles. However, Victorian Liverpudlians found that it did not give the spring needed for good dancing. It was then covered with a wooden platform, which is removed only for special viewings but has preserved its beauty perfectly. The architect worked closely with an engineer to provide an advanced system of heating and ventilation that formed a model for the future. (Historic England Archive)

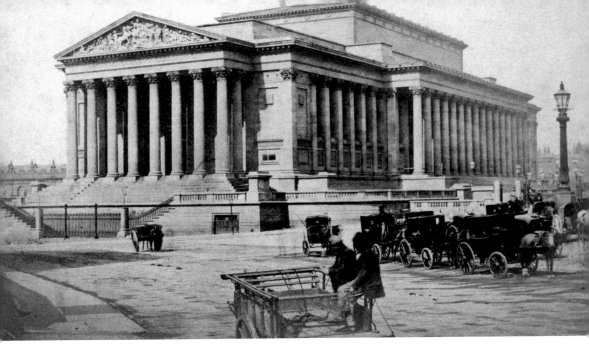

Above: St George's Hall, a Very Early Photo
This photo is remarkable for showing the south end of the hall as originally constructed. There is a gate with ornamental railings in front of steps that rise directly from the street leading to either side of the main flight up to the southern façade. The photo (salted paper print) is thought to date from around 1854–55, five years before the steps to the side were removed and replaced by a podium. This was to allow for road widening to accommodate the busy traffic already in evidence in the picture. The photo also clearly shows the sculptures in the triangular pediment, later removed in 1950 as they became unsafe. Just visible to the left is the tower of St John's Church, which was built in 1784. It was generally considered extremely ugly and closed in 1898. (Historic England Archive)

Below: St George's Hall, the Concert Hall
More beautiful still than the Great Hall, the Concert Hall is sumptuously furnished and embellished in classical style with Caryatid maidens appearing to support the balconies. The interior decorations were completed by the eminent architect Charles Cockerell after Elmes' early death. There is a civil court in addition to the assize court, which is open to view as a museum after the opening of the Queen Elizabeth II Law Courts in 1984.

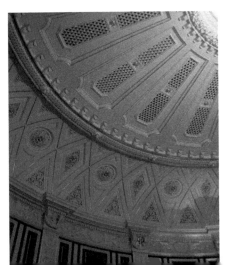

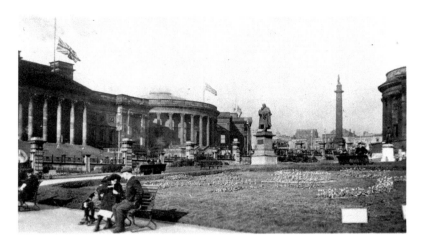

Above: William Brown Street

This First World War photo shows the cultural buildings that sprang up along William Brown Street during the latter part of the nineteenth century. Flags are flying half mast, maybe after particularly heavy carnage on the Western Front. The street was named after William Brown, merchant and banker (born in Ulster), who funded the first of the buildings: the Museum and Library. This is fronted by the row of columns to be seen to the left of the photo above. The Walker Art Gallery, paid for by the brewer Andrew Walker (a Scot), came next in 1877 just beyond the circular Picton Library completed in 1879. The opening of the Walker was celebrated with a public holiday. (Historic England Archive)

Below: Gladstone's Statue

Gladstone was born in Liverpool but of Scottish parentage. Liverpool benefited from the migration of many enterprising Scots who formed a significant part of the population. His statue is pictured soon after it was erected in 1904 in St John's Gardens at the back of St George's Hall (to the right). The Picton Library can be seen beyond on the far side of William Brown Street. The figure this side of the memorial represents Justice, with Truth on the other side. The statue of his great political opponent, Disraeli, is on the other side of St George's Hall facing the other way. (Historic England Archive)

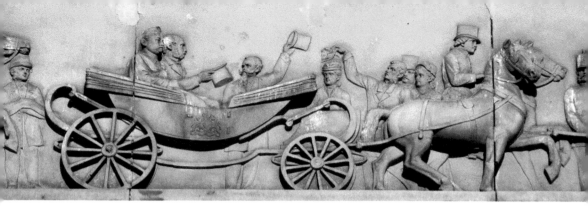

Above: Walker Art Gallery

On the wall of the Walker are four elongated panels that depict four royal visits to the city with Queen Victoria delineated here in a coach during her visit of 1851. The others record King John granting the first 'charter' in 1207, the embarkation of William III and his army at Hoylake in 1690, and the laying of the foundation stone of the gallery by the Duke of Edinburgh in September 1874. The gallery houses one of the largest art collections in England outside London. (© Historic England Archive)

Below: Walker Art Gallery Exhibition

In 1892 a naval exhibition was held in the gallery. Pictured is the Peninsular & Oriental Steam Navigation Co.'s display. Note the crowded walls with exhibits stretching to ceiling height – typical of art exhibitions of the era. The exhibition spaces, style of display and the nature of art have radically altered many times since then. Every two years a contemporary art exhibition is held in the gallery sponsored by Sir John Moores, founder of Littlewoods – a Liverpool-based company. Started in 1957, it offers the biggest painting prize in the UK. (Historic England Archive)

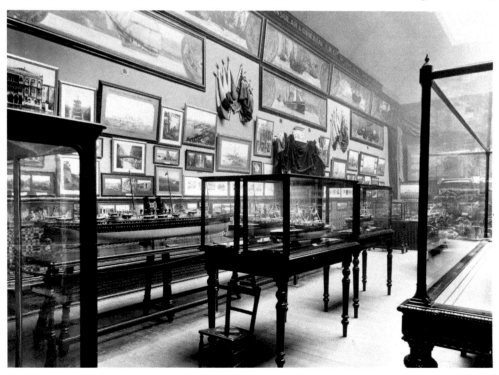

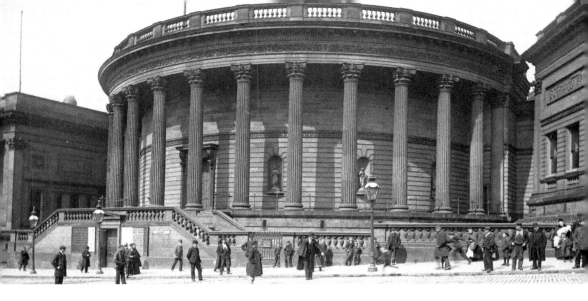

Above: William Brown Library and Museum and the Picton Library
In 1860 William Brown financed the library named after him and also the museum to house the Earl of Derby's natural history collection. Leading off the William Brown Library is the Picton Library, modelled on the Reading Room of the British Museum and opened in 1879. Named after Sir James Picton, Liverpool antiquarian, architect and politician, it was the first in the United Kingdom to be lit by electricity. The exterior design and positioning were carefully calculated to cover the change of axis between the existing buildings, as seen in this photo of 1895. The podium on which it is raised allows for the fall of gradient. (Historic England Archive)

Below: Wellington Column
A recent panorama shows the complete range of buildings along William Brown Street from the County Sessions House on the right, then the Walker Art Gallery and the Picton Library before the turn down to the William Brown Library and Museum. Completed in 1865, the column in the foreground commemorates the Duke of Wellington, who had died in 1852. His statue is on the top and around the base are plaques portraying his military victories. (© Historic England Archive)

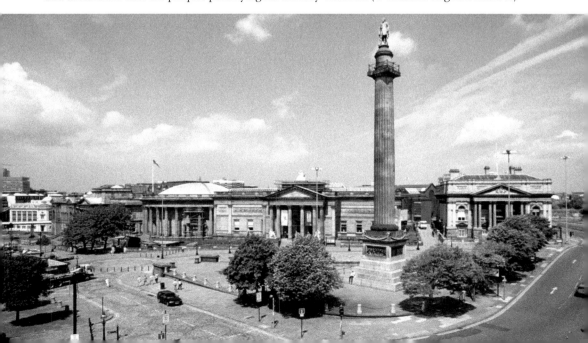

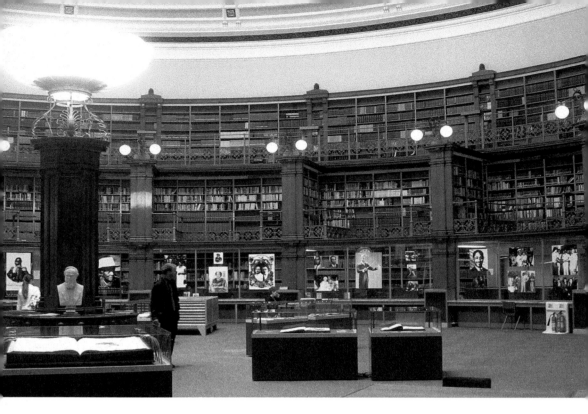

Picton Library and Audubon

Joseph Shipley, of Wilmington, Delaware, USA, a business partner of William Brown, was invited to the opening ceremony of his library, but, being unable to attend, made a donation to buy books for it. Appropriately, the Library Committee chose books with an American connection and purchased one of the library's greatest treasures, John James Audubon's *The Birds of America* for £168. Today a copy sells for several million pounds. It is remarkable for its life-size depictions of birds in 435 beautifully coloured plates. It used to be displayed in the Picton Library, as shown in its case here, but has now been transferred to the Hornby Library behind it. Audubon, failing to find a publisher in the United States, had come to Liverpool in 1826 and gained the confidence and connections in Liverpool to succeed with his great work in Britain.

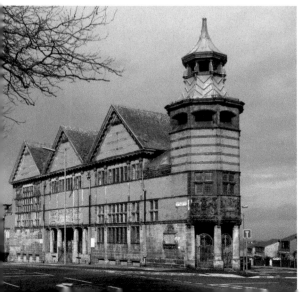

Everton Library

'Modernise everything' was the unbelievable motto of Thomas Shelmerdine, the Corporation Surveyor who designed this building in 1895. He was also the architect of many other libraries in the city, including the Hornby Library. Libraries like these have suffered closure in recent years but survived through community enterprise, as with Everton. The art nouveau design utilises the triangular site to great effect with its striking tower. Above the library on the ground floor and in the basement was a technical school. Separate reading rooms were provided for ladies and boys (but not girls, as elsewhere at the time). (Historic England Archive)

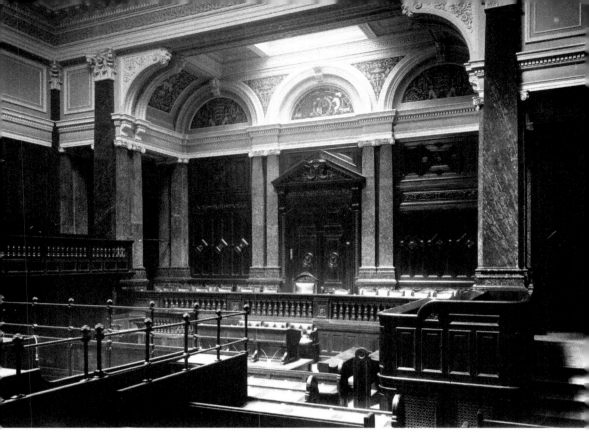

County Sessions House

The two final buildings on William Brown Street added at either end form a fitting conclusion to the line of civic splendour. In the meantime, pure classical taste had turned towards baroque and the County Sessions House at the top end, though not cultural, was externally decorated more lavishly than its predecessors, and inside, too, it was far more decorative than the assize court in St George's Hall, as this photo taken soon after its opening in 1884 shows. After closure as a court, it was for a time on show as a museum but unfortunately is not now open to public view. (Historic England Archive)

Museum Extension

The final addition to the range is the Museum Extension and Technical School built in rich classical baroque style. The impressive entrance hall is seen as it opened in 1901 with an ornate fireplace and mural over the door. Most of the Museum Extension is not used now for educational purposes nor are the public admitted. However, the beautiful hall is now used as the cafeteria and gift shop for the World Museum (as it is now called because the new Museum of Liverpool on the seafront displays items of local interest). (Historic England Archive)

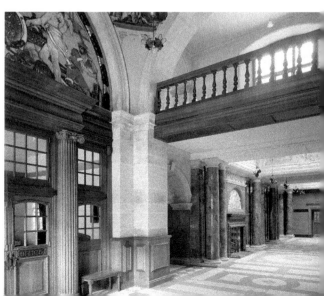

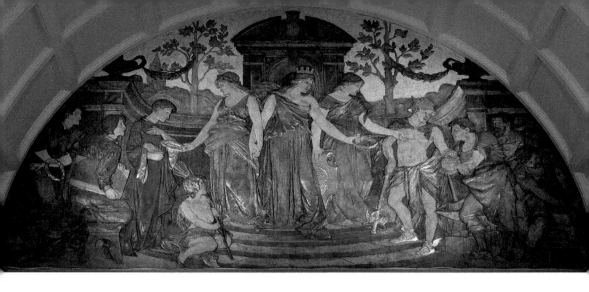

Above: Museum Extension Mural

A mural in the hall depicts a crowned figure of Liverpool who presides over the distribution of rewards to scholars (on the left) and industrial workers (on the right). The group of workers on the right includes a blacksmith, a labourer and a man with a bale of cotton. They are headed by Mercury, Roman god of commerce. In giving them a laurel wreath for victory, Liverpool is assisted by Minerva, Roman goddess and patron of art and industry. Typical of the age, all the scholars and workers are male (but those who give the rewards are female).

Below: Bluecoat School

The Bluecoat School, built in contemporary Queen Anne style, is the oldest educational establishment in Liverpool, and the oldest building in the city centre. Two Latin inscriptions on the building tell a story. One, stretching the full length of the façade below the triangular pediment, reads in translation: 'Dedicated to the promotion of Christian Charity and the training of poor boys in the principles of the Anglican Church. In the year of Salvation 1717.' The other, tucked up high away on the wall to the left as you enter the beautiful gates, can be translated: 'On 4th May 1941 struck from heaven by the torches of the enemy and partly destroyed. The same devotedly restored 1951.' It also survived demolition when it was earmarked for a failed proposal to site a monorail terminus there. The school was moved to new premises in Wavertree in 1906 and the building became an Arts Centre in 1927. (Historic England Archive)

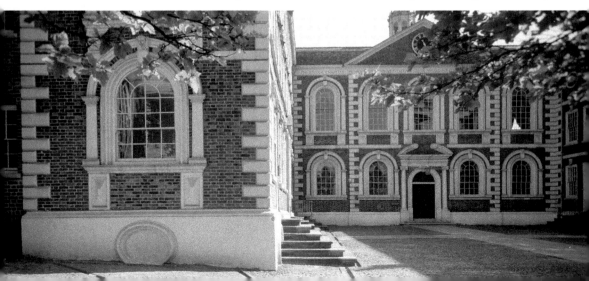

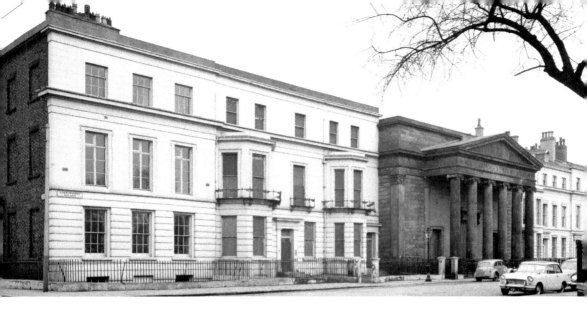

Above: University of Liverpool, Abercromby Square

The University of Liverpool's Victoria Building is the original 'Red Brick' designed by Alfred Waterhouse and opened in 1892. The university expanded over the surrounding area and adapted many buildings for its own purposes. One of the most successful has been Abercromby Square, built by John Foster Snr in the early nineteenth century and named after the general Ralph Abercromby, who died in action in the Napoleonic Wars. It incorporated St Catherine's Church, as illustrated in 1964. Unfortunately, initially damaged during the war, it was then demolished together with the adjacent terraces in 1966. The modern design of the subsequent redevelopment clashes with the other three sides, which have been beautifully preserved with their doorways designed to defend against rioting mobs. (Historic England Archive)

Below: University of Liverpool, Greenbank

All four Liverpool universities have adapted historic buildings for modern use. Hope University has transformed St Francis Xavier's Church and School into their Creative Campus, and LIPA (Liverpool Institute of Performing Arts) is based on the Institute School. Greenbank was originally the country home of the Rathbone family, who were prominent leaders in the cultural and political life of Liverpool from the early nineteenth century. It has now been converted into a university club for staff and students of Liverpool University, which has also named a building in honour of Eleanor Rathbone, who promoted women's rights, health and education. (© Historic England Archive)

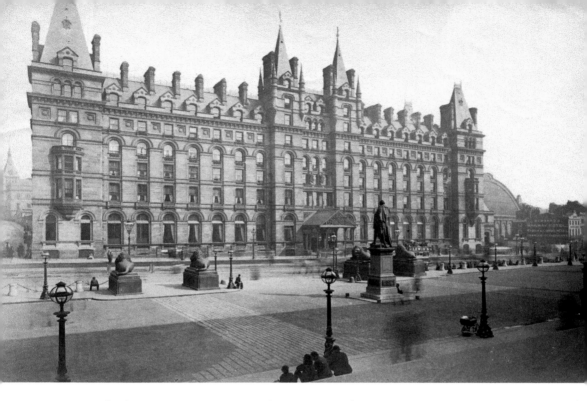

Liverpool John Moores University, North Western Hotel

The North Western Hotel, designed by Alfred Waterhouse, was completed in 1871 for the use of travellers arriving by the London & North Western Railway at Lime Street station. John Moores University has adapted it for student accommodation. On the photo of 1886 the tower that can be seen to the left of the hotel is part of Cope's Tobacco works on Lord Nelson Street. Disraeli's statue (centre-right) is standing in its original place on a 12-foot pedestal but was later moved onto the steps in front of St George's Hall to make way for the First World War cenotaph. (Historic England Archive)

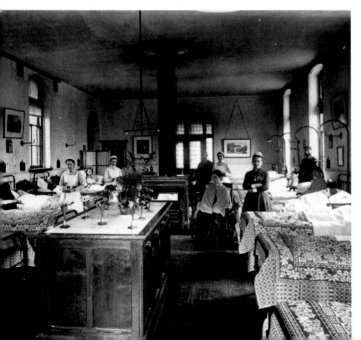

Liverpool John Moores University, Hahnemann Hospital

The Hahnemann Homeopathic was the first hospital in Britain to contain early hydraulic lifts and an innovative heating and ventilation system. It was built at the expense of the sugar magnate Henry Tate, who came from Chorley in Lancashire to set up his first shop in Liverpool. Tate North in Liverpool is one of his many other charitable donations (via the Tate Gallery in London). The Hahnemann Hospital was closed in 1976 but the building has been taken over by John Moores University. Here, men are visiting a women's ward in 1888. (Historic England Archive)

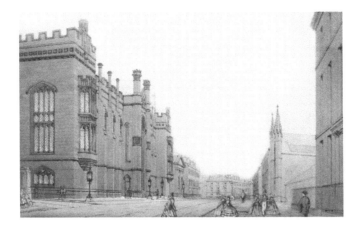

Above: Liverpool Collegiate School

The architect of Liverpool Collegiate School was Harvey Lonsdale Elmes, who also designed St George's Hall. With amazing versatility he designed the Collegiate School in a completely different High Tudor Gothic style, following – significantly – the traditions of Oxford and Cambridge colleges. It was the first of the great Victorian public schools, opened by William Gladstone in 1843, with a unique system of upper, middle and lower (commercial) schools under one roof. The Victorian print shows the Particular Baptist Church beyond it on the left and St Francis Xavier's Church opposite, now the Creative Campus of Hope University. Liverpool Collegiate upper school moved out in 1884 to form Liverpool College, and in 1904 the middle and lower schools combined to be controlled by the council.

Below: Urban Splash

After decades as a grammar school the Collegiate became a comprehensive in 1973, but following a disastrous fire was forced to close in 1985. The building has been converted into apartments by Urban Splash. The grandeur of the Gothic windows in front has been preserved by the ingenious design of two-storey apartments behind them, although they have lost their diamond-leaded panes. In complete contrast at the rear, the converted classrooms have a modern look influenced by Le Courbusier. Behind them, the octagonal hall was once the largest covered space of public assembly in the town, and housed a magnificent organ. Now, after being devastated by fire, remnants of the walls enclose a garden. (Historic England Archive)

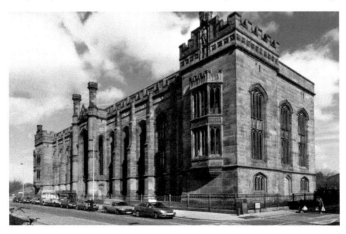

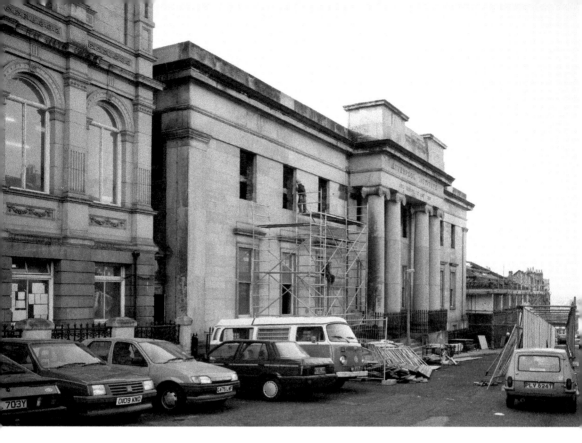

Liverpool Institute High School

A Mechanics Institute, founded in 1835, enabled working men to attend evening classes and so better their lot in life. In 1835 a new building was constructed (pictured in 1949). Its size and classical style rivalled the cultural institutions of the wealthy and emphasised its secular character (in contrast to the Anglican Collegiate). Lectures were given by well-known public figures such as Dickens, Trollope and Emerson. It developed a lower, upper and art school, becoming the Liverpool Institute and School of Arts in 1856. Taken over by the council in 1905, it was renamed the Liverpool Institute High School for Boys, which was attended by Beatles George Harrison and Paul McCartney. The photo could probably be dated by the cars! (Historic England Archive)

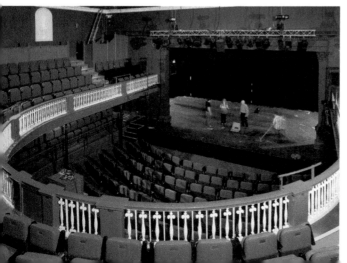

Liverpool Institute of Performing Arts (LIPA)

When the Institute closed in 1985, Paul McCartney funded its conversion into the Liverpool Institute of Performing Arts (LIPA), in which the university students are expected to train in all the three areas of acting, dance and music. The school hall has been converted into an auditorium in which the students can give public performances to display their talent. Shakespeare is celebrated with music and dance as well as drama. (Historic England Archive)

Worship

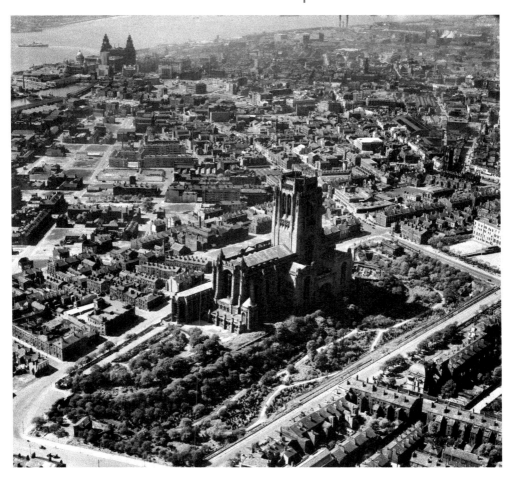

Anglican Cathedral

An aerial view of 1949 shows the Anglican cathedral in the foreground while in the distance is the unmistakable outline of the Liver Building and an Isle of Man steamer on the river. The cathedral is unfinished with the nave beyond the tower only just being started. At each new stage a temporary wall had to be constructed, which was then dismantled and moved when it was completed. The area to the left of the cathedral has now been cleared to form a car park and cathedral close. On the right is the cemetery designed by John Foster Jnr. The carriageways enabled the corteges to reach the graveyard level for burials. In 1901 a competition for a new design for a cathedral to be built on St James' Mount was won by twenty-three-year-old Giles Gilbert Scott, grandson of the architect George Gilbert Scott. Scott supervised construction, which began in 1904 with the Lady Chapel and continued until he died in 1960. The cathedral was only completed finally in 1978 to receive the RIBA (Royal Institute of British Architects) award for the year, a swansong of the Gothic Revival. If the Lady Chapel is included, it is the longest cathedral in the world. The organ is the largest in the United Kingdom, its Gothic arches are the world's highest and widest, and the peal of bells is the world's highest and heaviest. (© Historic England Archive. Aerofilms Collection)

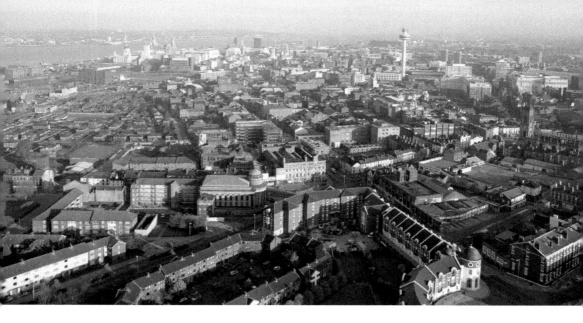

Above: River Viewed from the Cathedral
The superb view on St James Mount enables the cathedral to be seen clearly. As you look towards the river from the tower you can appreciate how the bombed-out areas, still bare in 1949, have been redeveloped and a cathedral close has been created. The Radio City tower (centre-right, opened in 1971) marks the cultural quarter of the city around St George's Hall. (© Historic England Archive)

Below: Cathedral Viewed from the River
This photo shows how the site for the cathedral was carefully chosen to make visual impact, as here from the river with the *Royal Iris of the Mersey* passing by. This exact view cannot be seen now as the development of the old King's Dock (already underway to the left including the Arena and Conference Centre) has obscured the Wapping Warehouse in the centre. The ship is not to be confused with the *Royal Iris*, which is in a derelict state. *Royal Iris of the Mersey* was the former ferry MV *Mountwood* refitted with a new nameplate. (© Historic England Archive)

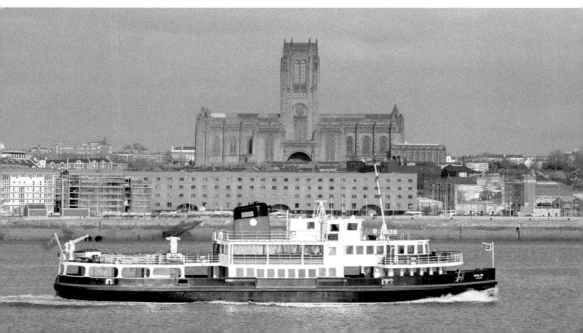

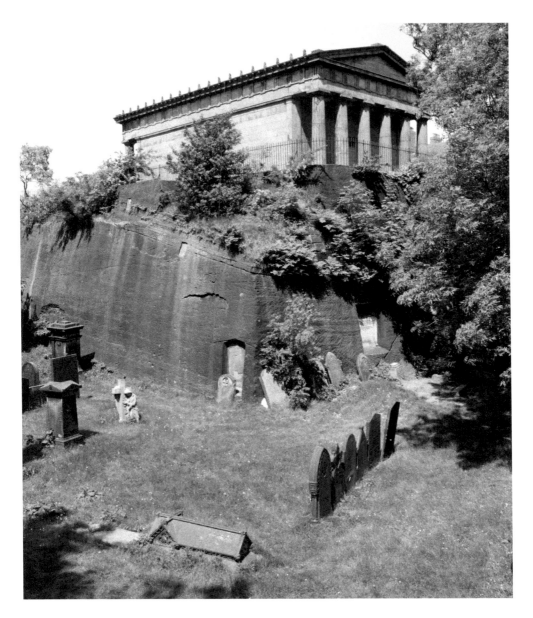

St James' Cemetery
An oratory by the entrance to the cathedral overlooks St James' Cemetery like a miniature Parthenon on the Acropolis in Athens. Both oratory and cemetery were designed by John Foster Jnr, who for two decades excelled in the neoclassical style of building in the city. St James' Cemetery was created out of a quarry whose stone had been used extensively in the construction of docks and buildings in the town. The oratory accommodated funeral services, before burials took place in the cemetery, and housed monuments for the deceased. It is built in the form of a temple in the Greek Doric order of architecture like the Parthenon. The elegant interior in the Greek Ionic style contains a collection of monuments, mainly neoclassical reliefs, many brought from demolished buildings in the 1980s. (© Historic England Archive)

LIVERPOOL ORPHAN BOYS' ASYLUM.

Robert H Winter aged 12 years died 17 May 1857
Thomas Jackson aged 12 years died 25 July 1860
John Twist aged 12 years died 3 Dec. 1861.
Owen Hughes aged 9 years died 18 June 1863
John Price aged 9 years died 24 June 1863
John Ross aged 14 years died 28 Nov. 1863,
Edward Atkinson aged 10 years died 11 Feb. 1864
William Kissock aged 9 years died 9 March 186

Above: Orphan Boys' Asylum Gravestone

The Liverpool Orphan Boys' Asylum was opened in 1854 on Myrtle Street for boys living within 7 miles of Liverpool Exchange and aged seven to eleven on the date of entry. No boys from workhouses were admitted. They had to certify their birth and baptism and the marriage and death of their parents. On leaving, the boys were generally found employment with local tradesmen. The asylum was relocated to Childwall in 1934. The dates on part of a grave headed 'Liverpool Orphan Boys' Asylum' range from 1857 to 1864 and the ages from eight to twelve. There does not appear to be any order in either of these two categories or the boys' names. 'Golden lads and girls all must, as chimney sweepers come to dust.' (© Historic England Archive)

Left: Huskisson Mausoleum

'Fear no more the frown of the great...' Huskisson, one of only two MPs for Liverpool at the time and a prominent national politician, was tragically killed at the opening of the Liverpool–Manchester Railway in 1830 (only a year after the cemetery was opened). As the train stopped at Rainhill to take on water, he stepped out of his carriage onto the track to heal a long-standing quarrel with the Duke of Wellington but was mown down by the locomotive *Rocket*. John Foster Jnr, the most eminent architect in Liverpool at the time, designed Huskisson's mausoleum in the style of the monument of Lysicrates in Athens. John Jnr himself is buried only a few feet away this side of it. (© Historic England Archive)

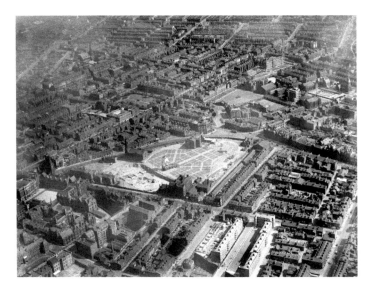

Above: Metropolitan Cathedral

Building is in progress for the Metropolitan Cathedral of Christ the King in the centre of this aerial photo of 1934. A design by Edwin Lutyens would have made the Metropolitan one of the largest cathedrals in the world, to beat the Anglican aathedral and rival St Peter's in Rome. The previous year work had started on the crypt, which can be seen to the bottom left of the site. On the right-hand corner of the site, the Medical Institution is on one side of the road junction with the Everyman Theatre alongside it and the Notre Dame training college opposite. The line of the railway cutting from Lime Street to Edge Hill can be seen as a dark shadow in the foreground running from the bottom-centre diagonally towards the left. (© Historic England Archive. Aerofilms Collection)

Below: Liverpool City Workhouse

The cathedral was built on the site of the Liverpool City Workhouse. The 'House of Industry' built in 1769–72 (pictured in a watercolour of 1844 below) could accommodate up to 600 inmates. It grew to become the largest workhouse in the land with an official capacity of over 3,000, although it did accommodate as many as 5,000 on occasions.

Cathedral Crown

Only the crypt of Lutyens' cathedral had been completed by the time the Second World War started and the money ran out. After the war a new competition for a more modest design was held. It was won by Frank Gibberd and the cathedral was dedicated in 1967. Its simple bold exterior is the major modern architectural attraction in the city. The crown is an iconic image, seen from all quarters of the city, in this instance Abercromby Square. The square enclosed a garden reserved for the surrounding residents' enjoyment and the centrepiece is the gardeners' tool shed, surely one of the most elegant in the land, designed in masterly classical style by John Foster Jnr. (© Historic England Archive)

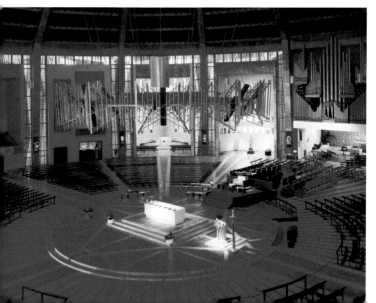

Cathedral Baldacchino

The altar of the Metroplitan Cathedral is set in the centre for maximum visibility. It is surmounted by a baldacchino representing the crown of thorns but cunningly concealing a sophisticated battery of mechanical equipment. Chapels or apses with a panoply of different colours radiate around but the overall impression is of a restful blue. The glass lantern in the tower above is patterned in three primary colours – yellow, blue and red – representing the Trinity. (Historic England Archive)

Above: Church of Our Lady and St Nicholas
The Church of Our Lady and St Nicholas is said to have been a place of worship since 1257, fifty years after Liverpool received its charter. A conjectural view of the second chapel built in the fourteenth century, based on a drawing or painting made in 1597, shows the Chapel of Our Lady standing on the site of St Nicholas' Church and the Tower in Water Street on the right. The Tower was constructed in 1406 by the Stanleys, who competed with the Molyneux family for influence in Liverpool, and were created Earls of Derby with their family home at Knowsley. The chapel was in the parish of Walton until the Liverpool parishes of St Peter and St Nicholas were formed in 1699. (Historic England Archive)

Below: St Nicholas' Church: The Spire That Collapsed
Between 1673 and 1718, as the population of Liverpool grew, extensions were made that included galleries, and a spire was added in 1746. The drawing shows the church and George's Basin in 1797. In 1810 as the congregation was gathering for the morning service and the bells were ringing, the spire collapsed onto the nave killing twenty-five people, most of them girls from a charity school. (Historic England Archive)

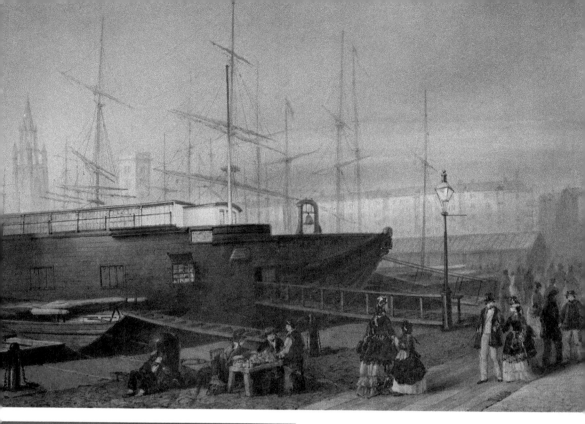

Above: The Mariners' Church
Within sight of St Nicholas' Church, as can be seen in a drawing of 1872, a former eighteen-gun sloop (the Tees) is moored in George's Dock. This was the Mariners' Church, which had been cleverly converted from the vessel gifted by the government. She seated 1,000 with an upper gallery overlooking the main worshipping area. A three-decker pulpit and organ were fitted for services on Sundays and Sunday schools. The ship was used from 1827, but ultimately sank at its moorings in 1872. (Historic England Archive)

Left: St Nicholas' Church: The New Spire
Soon after the collapse of the old spire the present decorative steeple was constructed. From 1813 to 1868 the church was the tallest building in Liverpool at 53 metres until surpassed by the Welsh Presbyterian church in Toxteth. The nave was rebuilt after destruction during the war but is now dwarfed by surrounding tower blocks. The corner of Tower Buildings is on the right, completed in 1910 on the site of the Tower, a town house fortified by the Stanley family in 1406 and used later as a prison before demolition in 1822. (© Historic England Archive)

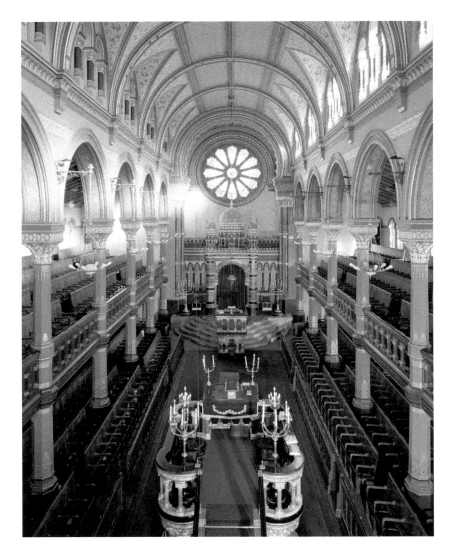

Synagogue

The opulence and position of the 'cathedral' synagogue at the start of one of the great radial roads of Liverpool reflect the wealth and confidence of the Jewish community at the time. Built in 1874 for the Liverpool Old Hebrew Congregation when they moved from the less salubrious Seel Street, it was designed by two Scottish Presbyterians, part of a strong Liverpool tradition of interfaith cooperation (the Anglican cathedral was designed by a Catholic, and the Catholic cathedral by an Anglican). Its exterior is unsurpassed as an example of Orientalism in Jewish architecture. The decoration of the equally sumptuous interior was paid for from the proceeds of one bazaar. The magnificent rose window and length of the lofty barrel-vaulted nave are equally dramatic. The synagogue is at the centre of a group of religious buildings that offered a rich selection of worship. From just outside it the Anglican cathedral is visible in the distance but nearer at hand is the Greek Orthodox church (opened in 1870 in the presence of the Archbishops of Canterbury and York). Sandwiched between it and the synagogue is the Anglo-Catholic Church of St Margaret of Antioch and others. (© Historic England Archive)

Deaf and Dumb Institute

On the other side of the Synagogue is the former Deaf and Dumb Institute, a charitable institution founded on Church of England principles and opened in 1887 by Princess Louise. Its chapel was designed in tiers so that the congregation could see the minister's sign language. A hall was used for lectures, meetings, dances and social gatherings. Women could socialise in a room of their own, and a hall was built later for men to enjoy snooker, chess, cards and other activities. The society provided an employment bureau, interpreters and financial help for the poor. The institute relocated to West Derby in the 1980s. For twenty years it operated as the Ibo Community Centre and Social Club for the Igbo (Ibo) people from Nigeria but it ceased when the building's fabric deteriorated, with the whole building now at risk.

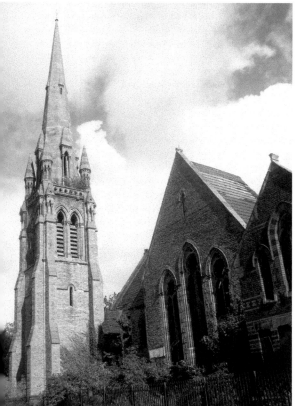

Welsh Presbyterian Church

Just over the road from the synagogue stands the spire of the Welsh Presbyterian church, once the tallest structure in town. It stood as a beacon over the Parliament Fields development, built without public houses by the Welsh for the Welsh. At one time the proud heart of a vibrant Welsh community of 80,000 that dominated the building industry in Liverpool, its spire, lecture rooms and vestries are now in a parlous state of disrepair. Just further along on opposite sides of Princes Road stood, at one time, the Mount Zion Welsh Methodist Chapel (now a Chinese church) and a Presbyterian church (which would be the focus of local Scots). Not far away are Swedish and German churches and the Chinese community.

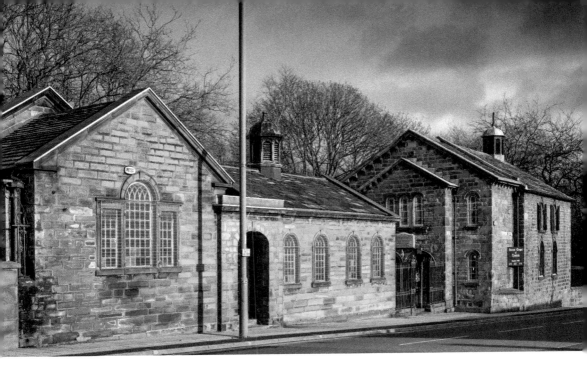

Ancient Chapel of Toxteth

The Ancient Chapel of Toxteth (the oldest ecclesiastical building in Liverpool) was built in the early seventeenth century for Nonconformist worship, first for Presbyterians and then Unitarians (with land granted by an Anglican, Richard Molyneux of Sefton). At that time Toxteth was an isolated rural community, but Jeremiah Horrocks (1618–41) lived in Toxteth and went to the University of Cambridge. He was the first person to demonstrate that the moon moved around the Earth in an elliptical orbit and the only person to predict the transit of Venus of 1639. The chapel was altered and enlarged in 1774 and there was an associated schoolhouse (nearer to the viewer in the photo). The interior is remarkable for its prominent pulpit, wooden box pews and gallery, which still survive. Toxteth was once a royal park and the name goes back to Viking times: Toca's staithe (landing place). (© Historic England Archive)

Key Street Unitarian Church

In 1791 the congregation of the Presbyterian chapel on Key Street built a Unitarian church on Paradise Street. The drawing to the left shows this delightful building that ceased to be used as a chapel in 1849 when the congregation moved to the more salubrious Hope Street. It was then converted into the Royal Colosseum and Music Hall, later the Queen's Theatre. Closing in 1923, it was used as a storeroom until bombed in the Second World War. (© Historic England Archive)

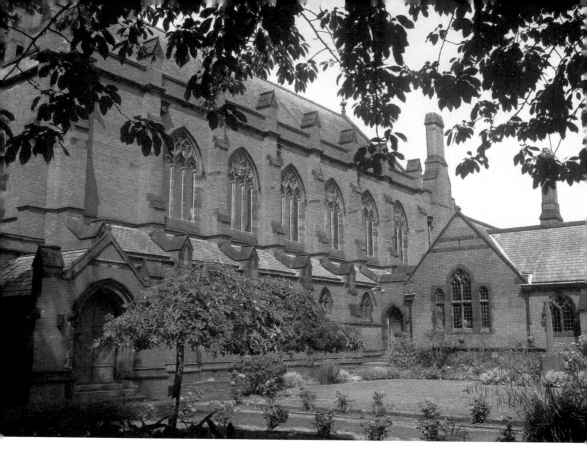

Ullet Road Unitarian

In 1869 a splendid Unitarian church was built on Ullet Road with adjoining library and a cloister (to the right of the photo) leading to a hall. With its William Morris windows, it is one of the finest groups of Nonconformist buildings in the country. The expense was borne by the many successful businessmen and merchants in nineteenth-century Liverpool who were Unitarians. They included leading figures, notably William Roscoe and the Rathbone families, and in the cloister are monuments erected to them and removed from an earlier chapel in Renshaw Street. It was one of three sumptuous churches in the Ullet Road, Sefton Park, area along with the Catholic St Clare's and the Anglican St Agnes'.

All Hallows

John Bibby, son of the founder of the Bibby Line, financed All Hallows in memory of his first wife, Fanny, daughter of Jesse Hartley, born on All Hallows' Eve. He engaged the finest window designers of the day: Edward Byrne-Jones, a founder member of the Pre-Raphaelites, and William Morris, a leader of the Arts and Crafts movement. The expense of these, one of the best collections of William Morris glass in the country, was such that even with contributions from family and friends there was nothing left for the bells or an endowment. Pictured is the *Adoration of the Lamb*, which Byrne-Jones claimed was his finest piece of work. (© Historic England Archive)

Homes

Above: Back-to-Back Houses

Little of Liverpool's notorious Victorian courts, often four storeys in height, survive, where the luckless inhabitants lived in utter squalor and deprivation. A four-storey set of the back-to-back houses that succeeded them have survived, as illustrated in the reconstruction above. It shows Duke's Terrace and the neighbouring timber yard as they may have appeared in the mid-nineteenth century, with the walls and floors cut away to reveal the arrangement of living space inside and the privies at the end of the row. The residential areas just inland from the waterfront ('Sailortown') were reckoned to be denser than those in any other civilised city and were infested with predatory emigration agents. With an extremely high level of poverty, deprivation and mortality, not surprisingly Liverpool was the first town in England to appoint a Medical Officer of Health in 1847. (© Historic England Archive)

Below: Terraces

The terraces that succeeded the back-to-backs surround Everton's ground Goodison Park in a 1938 aerial view. They were part of the rapid expansion of Liverpool in the latter part of the nineteenth century in which Welsh builders played a prominent part with access to brick and slate materials. The four-storey St Martin's Cottages, built in 1869 and now demolished, was one of the earliest examples of council housing in England. In contrast, the superior terraces of the Georgian quarter have survived – more, it is said, than in Bath. (© Historic England Archive. Aerofilms Collection)

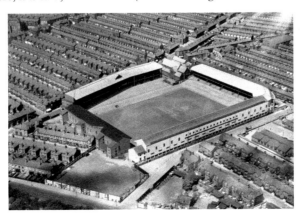

Above: Terraces Continue

During the latter part of the nineteenth century three storeys had given way to smaller two-storey properties. In this interwar photo three-storey terraced houses line Alma Street, Everton, but by the mid-1950s this area had been cleared. In 1966 the council proposed demolition of three quarters of terrace houses in the city. The Toxteth Riots, and disadvantages of alternative housing, promoted a rethink and many have been spared the wrecking ball. Some of these were refurbished successfully, one even winning the 2015 Turner Prize for visual art. (Historic England Archive)

Below: Tower Blocks

Pre-war, five-storey flats and tenements were considered as a way of solving the housing crisis. This was not enough and from 1954 tower blocks were built on a widespread scale, ever higher, culminating in the opening of the world's tallest block of prefabricated flats in 1966. But the social upheaval and restricted lifestyle were disastrous, compounded by the lag in time for the completion of shopping and leisure facilities. After a decade four out of five residents on one estate desperately wanted to leave. The blocks illustrated, known – significantly and openly – as the Piggeries, were demolished along with many others in the 1990s. (© Crown copyright. Historic England Archive)

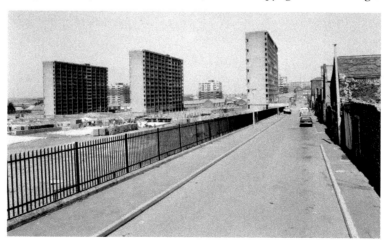

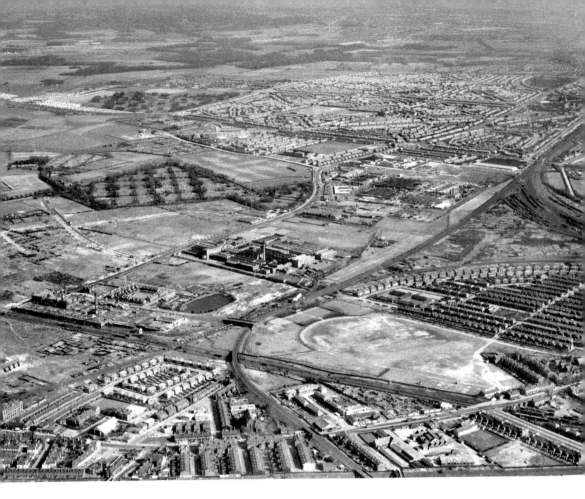

Industrial Aintree

The landscape photo of 1947 shows the area around Hartley's Village and factory in Aintree. The railway line from Liverpool through Kirkby to Wigan runs across the view slightly diagonally from lower left to the right. Alongside it on the left on the far side are the Hartley factory buildings with chimney to the right. Beyond that is the square of the village. Further away, stretching into the distance, are more factories: Jacob's Biscuit Factory and the Nelsons Preserving Co., which used to supply jam to Woolworth's. Further still is the Norris Green estate to the right and Croxteth Park to the left. Two tree-lined cemeteries stand out to the left: Everton and then West Derby. The area is criss-crossed by railway lines that were built at great cost during the latter part of the nineteenth century to serve the docks but are now closed. The Cheshire Lines loop (now largely cycle track) runs diagonally from bottom left to top right. It was originally constructed from Hunts Cross through Childwall and West Derby to Aintree and beyond. The track of two dock lines can also be observed: the line from the North Mersey docks comes in from the bottom towards the right and curves round to join the Cheshire Lines loop; from this sprouts a line marked by the curve of the houses built alongside it going off the photo centre-right towards the Huskisson Dock. The curving road in the foreground is Walton Vale. From 1936 tens of thousands of people were decanted from the city centre to places on the outskirts that were attractive to industry like Aintree, Speke and Kirkby. (© Historic England Archive. Aerofilms Collection)

Above: Hartley's Factory

William Pickles Hartley, jam maker, established his first factory in Bootle in 1874, which he moved to much larger premises in Aintree in 1886. Railway sidings at the factory enabled fruit to be received from farms and manufactured goods to be taken away. The factory ceased manufacturing in the sixties but the former dining hall illustrated here survives, although now used as industrial units. (Historic England Archive)

Below: Hartley's Village

A garden village adjacent to Hartley's factory was built in 1888 to house the key employees in suitable 'beautiful and healthy hygienic surroundings'. The village, now a conservation area, originally had a total of forty-nine houses surrounding a central bowling green, increased later to seventy-one. Here, the village is on the left with the entrance to the works in the distance on Spice Street. All the streets were given appropriate jammy names including Sugar Street, Red Currant Court and Cherry Row.

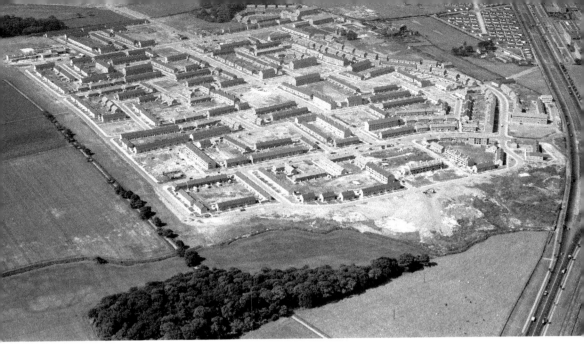

Above: Croxteth Housing Estate

A new housing estate is under construction at Croxteth in 1953. The main road to the right of the photo is the East Lancashire Road, the UK's first intercity highway from Liverpool to Manchester, later superseded by the M62. Alongside it to the left are rows of prefabs for people bombed out of Liverpool during the war, soon to be rehoused into superior accommodation – twelve years on. Croxteth was just one of the many estates that were built to alleviate the poor housing in Liverpool starting after the First World War, such as Huyton and Norris Green, which unfortunately lacked basic facilities. They were joined after the Second World War by Kirkby, Halewood, Speke, Cantril Farm (later named Stockbridge) and Netherley. (© Historic England Archive. Aerofilms Collection)

Below: Croxteth Hall

'Croxteth' is of Scandinavian origin – Krokr's staithe (landing place). The Norman ancestors of the Molyneux family were first granted lands in the area around 1100 and their home was at Sefton, a village 5 miles from Croxteth that has since given its name to the Borough of Sefton. In 1702 William, 4th Viscount Molyneux, added the 'Queen Anne' wing (pictured as it looks today) to the old Croxteth Hall. When the last earl died in 1972 the hall was taken into public ownership. The remainder of the estate is now a country park. It includes a walled garden, home to the Liverpool Botanic collections, one of the oldest in Britain, founded by Liverpool's William Roscoe in 1802. It houses rare orchids and national collections of other plants. (© Historic England Archive)

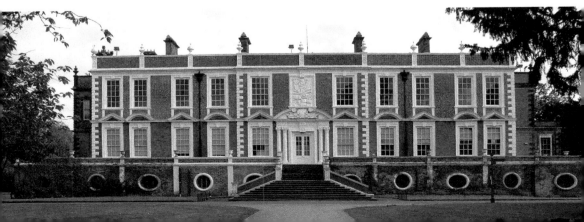

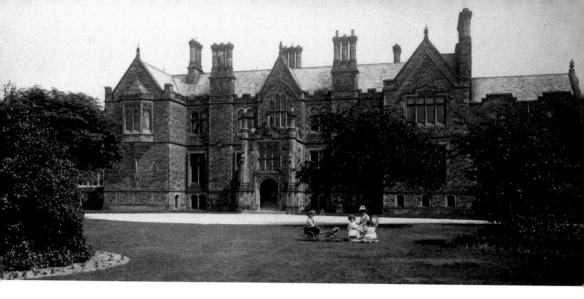

Above: Broughton Hall

A group, possibly the family of the owner Mr A. M. Taylor, is enjoying the extensive well-kept grounds. The hall was built in 1860 for Gustavus C. Schaube of Hamburg, a prominent Liverpool merchant. The Sisters of Mercy purchased it in 1925 and founded Broughton Hall High School in 1928. Eventually the school moved completely to new school buildings on the site and the Sisters returned to their old home. (Historic England Archive)

Below: Broughton Hall Interior

A set of photos were taken in 1888 by the Liverpool firm of S. J. Waring (later Waring & Gillow) to publicise their furniture. The interior of the morning room is typical of the many merchant 'palaces' built in or near Liverpool in the heady days of Victorian mercantile prosperity. Waring & Gillow (who later joined up with Maples) built up a reputation for supplying high-quality furniture to the richest families in the country. They fitted out luxury yachts and liners including the royal yacht *Victoria and Albert* and, later, the *Lusitania*, *Queen Mary* and *Queen Elizabeth*. (Historic England Archive)

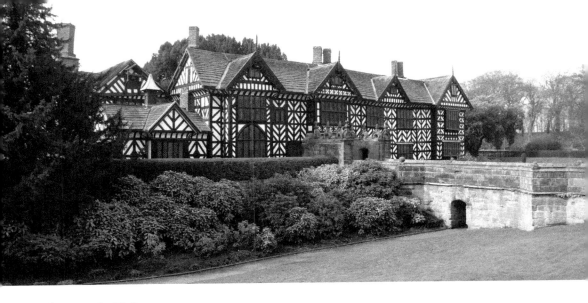

Above: Speke Hall

The hall is a wood-framed wattle and daub Tudor manor house, one of the finest examples of its kind. The Great Hall was the first part of the house to be built in 1530. By the end of the century all other additions had been completed. The remains of the moat can be seen in the foreground. From 1986 the house has been run by the National Trust. 'Speke' is of Scandinavian origin 'spaec' – ('place near brushwood'). (© Historic England Archive)

Below: Speke Hall Interior

In the hall of the house is a large full-length portrait portraying the 'Child of Hale', a local lad reputedly 9 feet 2 inches tall who was taken to the court of James I. However, the finest feature of the interior is the early Jacobean stucco ceiling of the Great Parlour, which you can see in this image below. (© Historic England Archive)

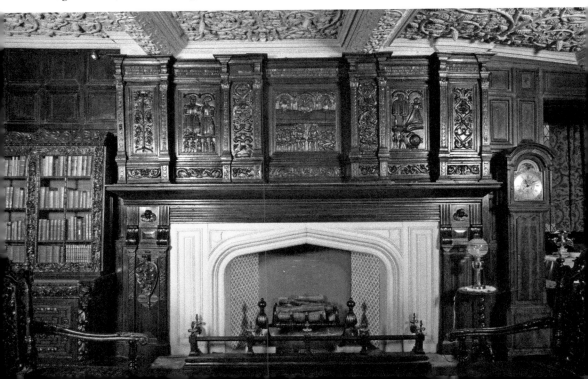

Leisure

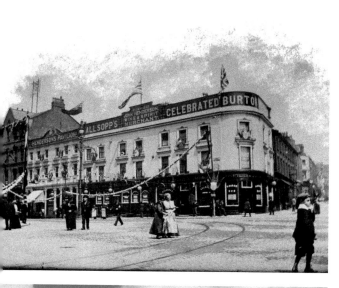

Vines' Wine and Spirit Vaults
This photo, probably dating from the last quarter of the nineteenth century, shows Henderson's Pavilion and Alfred B. Vines & Son's Wine and Spirit Vaults at Nos 77–87 Lime Street. It appears that great celebrations were taking place as the flags and bunting are flying, possibly Queen Victoria's Diamond Jubilee in 1897 but it could be anytime from its building in 1867. The right-hand eight bays of the building were demolished and replaced by the Vines public house, presumably named after the owner of this previous building. John Henderson was the proprietor of the Pavilion public house to the left of the range, to which he gave his name. It appears that the upper floors of the right-hand eight bays may have been in use as a hotel at the time of the old photograph. (Historic England Archive)

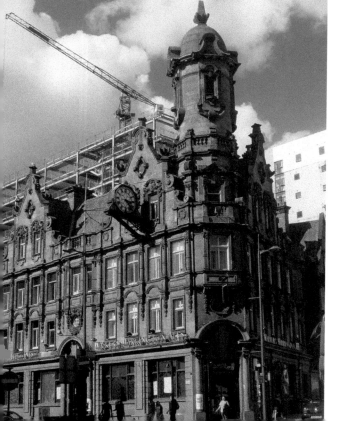

Vines
Its replacement, built by the Liverpool brewer Robert Cain in 1907, has an extravagant exterior that is matched by the interior. The corner tower above the main entrance is elongated from the keystone over the door to the dome and obelisk on top, and the whole is embellished with baroque exuberance. The architect Walter W. Thomas, a jovial Welshman, also designed the Philharmonic Dining Room and, marrying into the Lewis family, part of their department store.

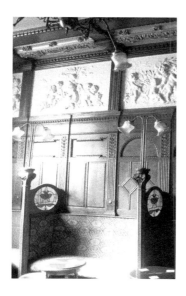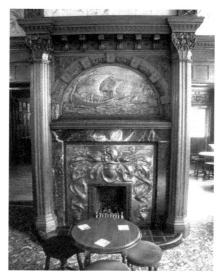

Above: Vines Interior

Inside the Vines, semi-secluded seating for two on padded benches is created by attractive coloured-glass dividers with playful scenes of cherubs enjoying themselves. Repoussé work enhances a fireplace framed by delicately carved columns in classical style. Also worth seeing are mahogany caryatids (classical columns in the form of female figures), a beaten copper bar and the coloured-glass ceiling in the function room.

Below: Philharmonic Dining Room

There are many other extravagant Victorian pubs in Liverpool. The finest is the Philharmonic Dining Rooms, also built for Robert Cain in 1898–1900, opposite the Philharmonic Hall. The interior is decorated in musical themes that relate to the concert hall over the road and rooms are entitled with the names of famous composers. Illustrated is the bar and, like the Vines, decorations are executed on repoussé copper panels with plasterwork. There are also items in mahogany and glass. The gentlemen's urinals are unusually ornate, constructed in 'a particularly attractive roseate marble'. Women are often invited in and pleased to have a look! (© Crown copyright. Historic England Archive)

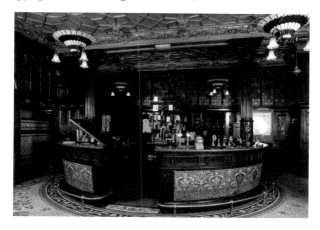

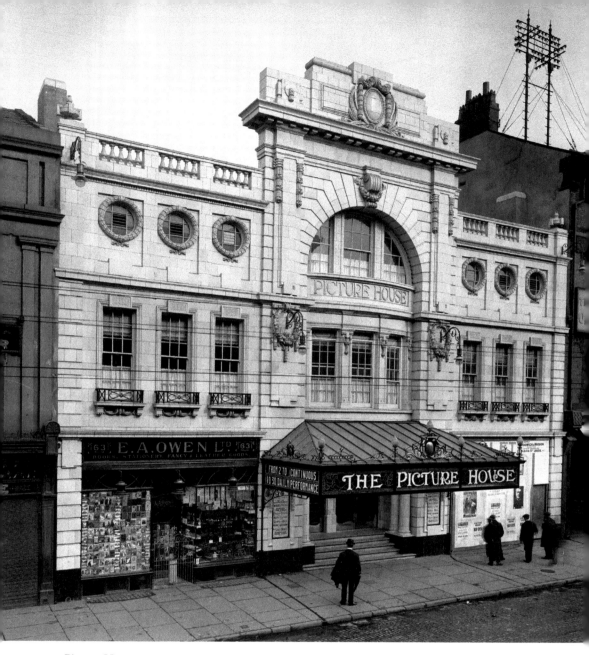

Picture House

This photo of the Picture House cinema in Lime Street taken shortly after it had opened in 1912 shows people looking to see what was on offer – not surprisingly as it was the first purpose-built cinema in Liverpool. Patrons would be treated to an auditorium that had the feel of a theatre with a full orchestra to accompany the silent films. Behind the ornate façade on the first floor was a luxurious café aimed at attracting an upmarket clientele. It was in competition with the Tivoli opposite – a converted theatre. In 1913 Liverpool had eleven theatres and thirty-two cinemas. By 1931 the number of theatres had nearly halved and the number of cinemas had more than doubled. The largest of these were concentrated in the vicinity of Lime Street. (Historic England Archive)

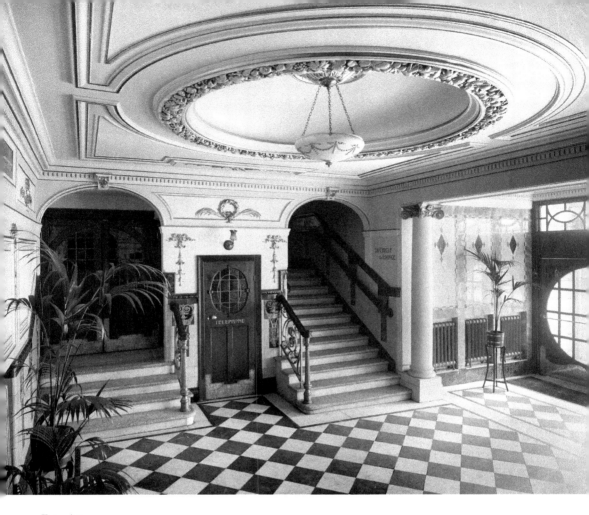

Futurist

When the Picture House opened, the patterned tiled floor and elaborate marble and plaster decoration of the foyer presented an immediate aura of splendour to patrons. Changing its name in 1920 to the Futurist, the Picture House was joined by yet two more cinemas in Lime Street: the Scala and the Forum. By 1982 all three were controlled by EMI, who adapted the Forum to triple screen and closed the Scala and Futurist. The nearest operating cinema is now FACT, a new build, coincidentally part of the 'Picturehouse' group! (Historic England Archive)

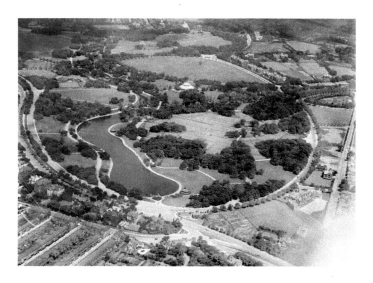

Above: Sefton Park

South Liverpool is especially blessed with the huge swathe of Sefton, Princes and Calderstones parks. Tree-lined avenues with dual-carriageway central reservations abandoned by trams add to the open green spaces and the biggest open space of all – the Mersey. A European competition was launched to design the 400-acre Sefton Park. It was won by French landscape architect Édouard André, who was assisted by Liverpool architect Lewis Hornblower. Plots of land on the perimeter were sold for housing, which helped in the funding of the layout of the park. Late Victorian and Edwardian houses of quality were thus built around the park, particularly on the west side, out of view on the left in the aerial photo taken in 1928. (© Historic England Archive. Aerofilms Collection)

Below: Sefton Park Lake

The park was opened in 1872 by Prince Arthur, who dedicated it 'for the health and enjoyment of the townspeople'. This postcard view dating from the turn of the nineteenth century shows the boating lake that offered the enjoyment of swans, ducks, rowing boats and a pirate ship, which lasted until the 1990s. The cricket club, now over 150 years old, welcomed W. G. Grace in 1877. Other attractions included an aviary and concerts at the bandstand, said to be the inspiration for the Beatles' song 'Sgt Pepper's Lonely Hearts Club Band'. In springtime thousands of daffodils planted by charities bloom in a 'Field of Hope'. (Historic England Archive)

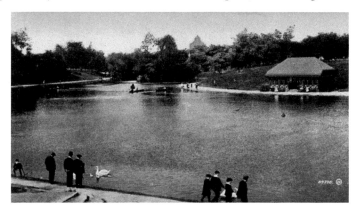

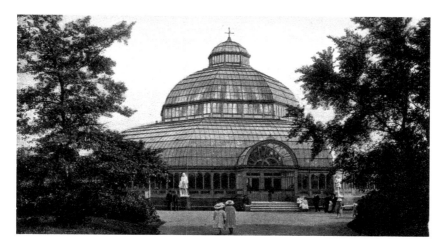

Above: The Palm House
The Palm House can be seen in the aerial view opposite standing out in the white in the centre beyond the lake. Pictured in the early 1900s, it was donated in 1896 by Henry Yates Thompson, newspaper proprietor and collector of illuminated manuscripts, born of a Liverpool family. He also gifted statues that surround the Palm House, celebrating Liverpool's maritime pride and commemorating major contributors to botanic science and gardening. The heating system underneath the floor and the collection and distribution of water from the roof were of advanced design. (Historic England Archive)

Below: Restoration of the Palm House and Eros Fountain
An Edwardian view shows one of the original statues inside the Palm House. The glass, damaged during the war, was reglazed in 1950 but the structure deteriorated and closed in 1980. It was rescued by the Friends of Sefton Park Palm House, reopened in 1993 and then fully restored by Heritage Lottery and European funding. It is now a popular visitor attraction and available for hire. In 1932 a replica of the Shaftesbury Memorial Fountain in London's Piccadilly Circus was unveiled nearby. It was replaced in 2008 by a copy made from bronze and aluminium, and the original now resides in Liverpool's Conservation Centre. (Historic England Archive)

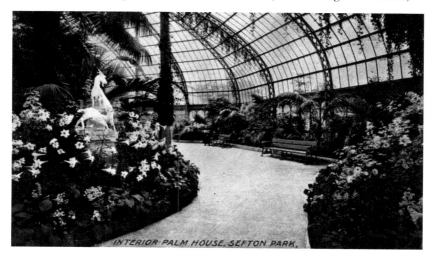

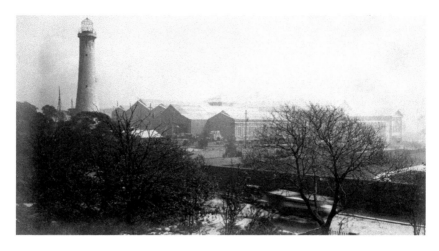

Above: Wavertree Park and the Shipperies Exhibition
In 1886 the first provincial international exhibition was held in Wavertree Park. It aimed to promote Liverpool as the second port and city in the British Empire, a gateway to it and from there to Britain. When the exhibition was opened by Queen Victoria with great pomp and ceremony, Lewis's sponsored a visit by the largest ship of the time, the *Great Eastern*. Over 3 million visitors came to see not just British but also overseas manufactures and mechanical inventions. It was jocularly referred to as the Shipperies but officially it was the International Exhibition of Navigation, Commerce and Industry. The photo shows some of the pavilions and a life-size copy of the Eddystone Lighthouse, but not unfortunately the grand triumphal arch. (Historic England Archive)

Below: Botanic Gardens
In 1802 William Roscoe, politician, banker, botanist, historian and poet, founded a Botanic Garden near Mount Pleasant (now part of the university). It was laid out very formally for study purposes, although walks along its peripheral serpentine paths were also enjoyed. Its design was copied as far afield as Philadelphia and Calcutta. It was later relocated to Wavertree and a postcard shows the lake and the conservatory at the height of their prosperity in the early 1900s. (Historic England Archive)

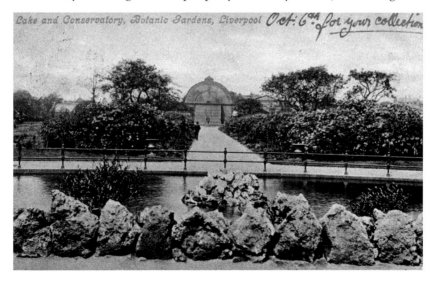

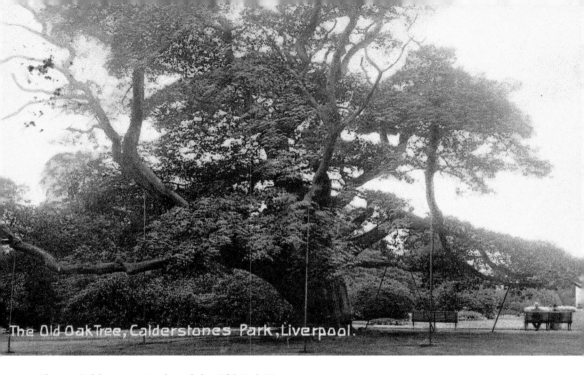

The Old Oak Tree, Calderstones Park, Liverpool.

Above: Calderstones Park and the Old Oak Tree
The glasshouses at the Botanic Gardens were shattered by a stray German bomb during the war but the botanic garden specimens were resurrected at Calderstones Park. The parkland had been bought in 1902 by Liverpool Corporation from Charles McIver, co-founder of the Cunard Line. With the addition of the adjoining estate of Harthill, the Corporation transformed it into the current 94-acre park. This old oak tree, pictured 100 years ago, is reputed to be 1,000 years old.

Below: Calderstones
Much older still are the Calderstones themselves: six large stones or megaliths that stand in a conservatory in the park. Four thousand years ago they were carved out of the local rock with spirals, concentric circles and mysterious symbols found as far away as Spain. They were arranged in a cave-like structure called a 'dolmen' and then covered in earth. Two thousand years ago people buried their dead in the mound. Exposed in the nineteenth century, the stones were moved from near their original site on the edge of the Harthill Estate (now the park) to their present site in 1954. In the meantime they had collected some additional modern indecipherable signs (graffiti!). They thus preserve a record of Liverpool unequalled in length of time.

About the Archive

Many of the images in this volume come from the Historic England Archive, which holds over 12 million photographs, drawings, plans and documents covering England's archaeology, architecture, social and local history.

The photographic collections include prints from the earliest days of photography to today's high-resolution digital images. Subjects range from Neolithic flint mines and medieval churches to art deco cinemas and 1980s shopping centres. The collection is a vivid record both of buildings that are still part of everyday life – places of work, leisure and worship – and those lost long ago, surviving only in fragile prints or glass-plate negatives.

Six million aerial photographs offer a unique and fascinating view of the transformation of England's towns, cities, coast and countryside from 1919 onwards. Highlights include the pioneering photography of Aerofilms, and the comprehensive survey of England captured by the RAF after the Second World War.

Plans, drawings and reports provide further context and reconstruction artworks bring archaeological sites and historic buildings to life.

The collections are housed in a purpose-built environmentally controlled store in Swindon, which provides the best conditions to preserve archive items for future generations to enjoy. You can search our catalogue online, see and buy copies of our images, as well as visiting our public search room by appointment.

Find out more about us at HistoricEngland.org.uk/Photos
email: archive@historicengland.org.uk
tel.: 01793 414600

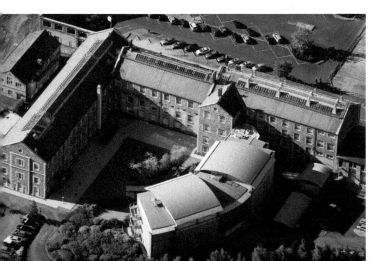

The Historic England offices and archive store in Swindon from the air, 2007.